EX LIBRIS

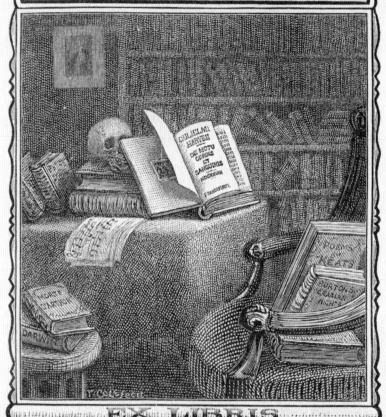

Show me the books he loves and I shall know
The man far better than through mortal friends
*Dr. S. Weir Mitchell*

EX LIBRIS

HERMAN THEODORE RADIN

# EX LIBRIS
## THE ART OF BOOKPLATES

MARTIN HOPKINSON

Yale University Press

I am much indebted to Alison Wright, Margaret Schutzer-Weissman, Sheila O'Connell, Axelle Russo, Charlotte Cade and my editor, Felicity Maunder, for their help in facilitating the publication of this book.

Martin Hopkinson has asserted the right to be identified as the author of this work

First published in 2011 by The British Museum Press
A division of the British Museum Company Ltd
38 Russell Square, London WC1B 3QQ

www.britishmuseum.org

First published in 2011 in North America by
Yale University Press
302 Temple Street
P.O. Box 209040
New Haven, CT 06520-9040

www.yalebooks.com

ISBN   978-0-300-17163-1

Library of Congress Control Number: 2010942172

Cover designed by Bison Bookbinding & Letterpress
Interior designed by The Old Chapel Graphic Design
Printed in China by Toppan Leefung Printing Ltd

The papers used in this book are recyclable products and the manufacturing processes are expected to conform to the environmental regulations of the country of origin.

*Frontispiece:* Timothy Cole (1852–1931), Bookplate for Herman Theodore Radin.
December 1913. Photograph of a wood engraving, 9.7 x 6.7 cm.
Radin (b. 1878, d. ?) was a New York doctor, print collector and writer on medical bookplates, who gave his substantial collection of prints to the New York Public Library.

# INTRODUCTION

Bookplates are prints, drawings or watercolours designed by professional and amateur artists to be inserted into the front of books to display ownership. They are sometimes known as *ex libris*, from the Latin for 'from the books of'. Originally a mark of prestige and status in society, by the twentieth century the range of people who commissioned or used them had become very wide. This book presents a personal selection from the substantial collection of bookplates held by the British Museum, many of which have never been published before.

## EARLY BOOKPLATES

Bookplates were first produced in the last quarter of the fifteenth century. The inspiration for making them derives from the medieval practice of including portraits or other means of identification at the front of illuminated Books of Hours (prayer books) to indicate their ownership. Around 1440 Johannes Gutenberg in Mainz invented the printing press with movable type, which led to the possibility of printing many identical copies of the same texts. Nevertheless, early books were very precious and prestigious items (only about 180 copies of Gutenberg's famous Bible were printed when it was published in 1455). Shortly after Gutenberg's death in 1468 book owners began to commission artists to design and make woodcuts with images of personal significance to announce their ownership. These early bookplates were sometimes hand-painted in imitation of the painted pages in manuscripts. The images were nearly always the owners' coats of arms, often treated in a highly decorative way. At a time when lineage was very important, a coat of arms, after all, provides the identification not only of the first owner but of the family

within which ownership of the book will descend through inheritance. It was very rare for a bookplate to be a portrait; however, the British Museum owns an early sixteenth-century bookplate designed by Albrecht Dürer, one of the greatest artists of the age, with a portrait of the Nuremberg humanist Willibald Pirckheimer (see p. 11). The plate is still inside a book that was once in Pirckheimer's library.

## BOOKPLATES FROM 1500 TO 1850

Over the next 350 years the vast majority of bookplates continued to be heraldic or armorial, often extremely ornate and sometimes of very high quality. In the eighteenth century designers followed the Rococo movement in introducing styles and shapes deriving from the same sources used by leading French and German decorative artists for intricate silverware and frames. At this period some bookplates began to include images of books – known as book-pile plates – or libraries, while others incorporated some suggestion of landscape. The latter tend to feature memorial stones and generally invoke the Latin saying '*Et In Arcadia ego*', 'Even in Arcadia I exist', making reference both to death and to the continuation of the pleasures of life. Such plates identify reading as a leisure activity to be enjoyed and also link it to a tradition of classical learning. They show an appreciation of man's place in the natural world, an idea that derives from classical humanism.

## NEW OWNERS AND THE PICTORIAL BOOKPLATE

Although armorial bookplates continued to be made in large numbers, the market for bookplates extended in the nineteenth century to include the middle classes, who did not necessarily have coats of arms. Academics, museum officials, ministers of the church, lawyers and other professional

people, along with figures in the literary world, were all attracted by the idea of commissioning bookplates. These men and women were more interested in celebrating their own lives and achievements than in displaying their lineage. Artists, designers and architects – particularly those involved in the Arts and Crafts Movement – also began to make plates for themselves and to commission them from others.

The mid-nineteenth century heralded the advent of the fully pictorial bookplate. The images chosen often reflect the owner's life and interests, and express the intimate connection that people held with their books at that time. Some pictorial bookplates were inspired by the emblems of the north Italian sixteenth-century jurist Andrea Alciato, in which an image conveys an idea or concept (the emblem books of Alciato and his successors were published in many European countries and widely circulated, providing the source of much symbolic imagery in art throughout Europe from the end of the sixteenth century onwards). Others took their imagery from classical philosophy or from poetry, both historical and contemporary (for example the works of the French Parnassians and Symbolists, two movements that invoked images in their poetry, were important for bookplate designers and owners alike). Another common theme was punning, with various elements in a design combining to form the owner's name.

Just as the audience for bookplates broadened in this period, so too did the sources for the imagery used in them. Oriental, particularly Japanese, art had been newly discovered by European and American artists and collectors in the years following Commodore Perry's 1853–4 visit to Japan, which resulted in the country being opened up to foreign trade. Very soon these artists began to include elements derived from their newly acquired knowledge in bookplates. It did not take long for the art of the Indian subcontinent, south-east Asia and the islands that make up present-day Indonesia also to

attract their attention. By the end of the nineteenth century bookplates were particularly popular among those associated with theosophy, the occult and freemasonry, and decadence. Reflecting the contents of their owners' libraries, they employed increasingly esoteric and hermetic imagery, the meaning of which is sometimes only immediately apparent to initiates. From the 1880s onwards nudity became a significant feature in German and Austrian bookplates. This was a period when the erotic bookplate developed rapidly, a genre that continues to flourish today.

## THE STUDY OF BOOKPLATES

Towards the end of the nineteenth century there was an enormous expansion in interest in the history of bookplates and in forming large collections of them. Exchange systems were set up so that individuals could swap works for those which they particularly wanted to own. John Byrne Leicester Warren, Baron de Tabley's *A Guide to the Study of Bookplates*, published in 1880, was the first in a succession of volumes issued in Britain and America to provide bookplate owners with a historical background. Ex Libris societies proliferated in Europe and America, and a number of journals were created to publish information about both historical and contemporary bookplates. In Britain the Ex Libris Society was founded in 1891. Annual exhibitions of bookplates were held and complete private collections were shown to the public. Volumes began to appear that were devoted to particular types of bookplate. A few British artists published collections of their bookplates in small volumes: they included the amateur Major Ernest Bengough Ricketts (see p. 40); the Edinburgh painter, caricaturist and printmaker Joseph Simpson (pp. 48 and 49); Edward Gordon Craig, an artist who revolutionized stage design (pp. 46 and 47); James Guthrie, a wood engraver and leading figure in the field

of the illustrated book; and Frank Brangwyn, whose paintings, prints and decorative work were influential throughout Europe (pp. 88 and 89).

The golden age for the collecting and appreciation of bookplates was roughly from 1890 to the mid-1920s; no doubt the worldwide financial collapse in 1929 was largely responsible for its public demise. At the same time merchandising at the lower end of the market had changed, and it had become possible to acquire very cheap bookplates in shops. One could fill in one's own name on these mass-produced plates, most of which had no great pretensions as artistic designs. It should not be thought, however, that the production of high-quality artist-designed bookplates ceased. Instead they became the preserve of a much more enclosed private world of bibliophiles. Taste in bookplate design has always been relatively conservative, so one can find virtually no evidence, for example, of the influence of Cubism or Abstraction during the years following the First World War, or even today.

## BOOKPLATES SINCE 1930

A resurgence of high-quality artist-designed bookplates in the 1970s coincided with the revival in Britain of the technique of wood engraving, and a proliferation in the art world of the production of multiples of all kinds. This reawakening of scholarly and collecting interest led to the founding in 1972 of the Bookplate Society in England, and of two journals, *The Bookplate Journal* in 1983 and *Bookplate International* in 1994. Fine bookplates continue to be made, and a stream of studies of individual designers and various bookplate topics have appeared in Britain over the last forty years. It should be noted that this small book does not attempt to cover the whole range of bookplates, and does not reflect, for instance, the thriving creation of works in Belgium, Italy, eastern Europe, Russia and Japan.

WOLF TRAUT
(1486–1520)
*Bookplate for
Christoph Scheurl II*
1512, Woodcut
35.4 × 25.2 cm

This is one of the
most elaborate early
bookplates, made
for the Nuremberg
lawyer and diplomat
Christoph Scheurl
II (1481–1541).
It incorporates
biblical and classical
texts and a brief
biography of Traut's
patrons, as well as
the coats of arms of
the Scheurl (left)
and Tucher (right)
families (Scheurl's
mother was Helena
Tucher). The goat
and man from the
shields support the
figure of Fortuna,
identifiable by her
flowing hair.

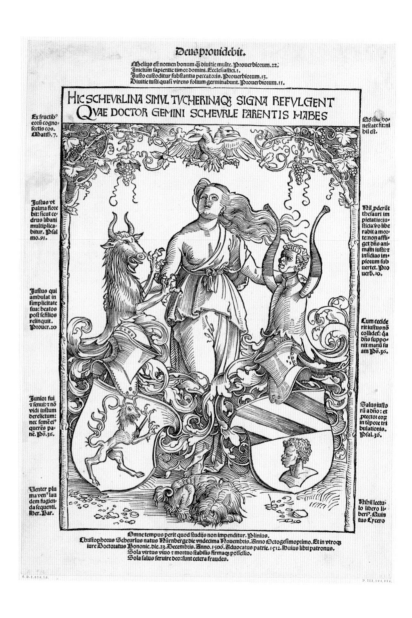

ALBRECHT
DÜRER
(1471–1528)
*Bookplate for Willibald
Pirckheimer*
1524
Engraving
16.4 × 10.2 cm
(book cover)

The leading
Nuremberg
humanist
Pirckheimer (1470–
1530) was a close
friend of the artist.
He used this portrait
as a bookplate for
many volumes in his
extensive library.
This particular sheet
was pasted inside
his copy of Cicero's
*De Rerum Natura*,
published by P. Junta
in Florence in 1516.

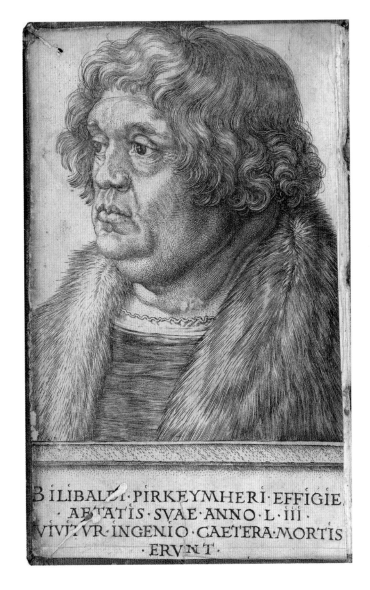

TEODORO
VIERO
(1740–1819)
*Bookplate for the artist*
Engraving
10.4 × 6.8 cm

This engraver,
printer and
publisher chose the
lion, the emblem of
Venice, as the image
for his bookplate
to advertise his
citizenship of that
city.

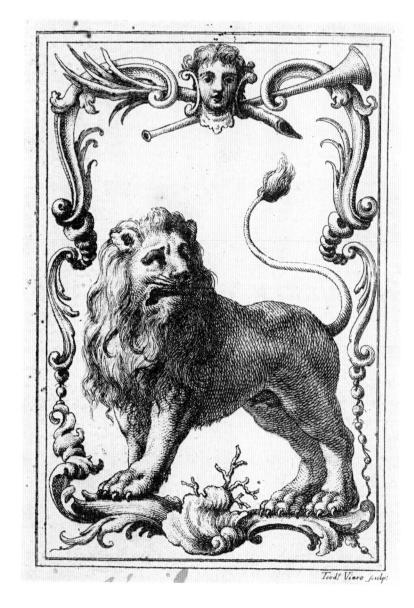

REV. WILLIAM
BREE
(1754–1822)
*Bookplate for Rev.
William Thomas Bree*
Etching
9.7 × 7.7 cm

Bookplates were
often executed by
amateur artists.
The Reverend
William Bree, a
prolific printmaker,
made this etching
for his son, the
Reverend William
Thomas Bree
(*c.* 1785–1863),
Vicar of Allesley,
near Coventry in
Warwickshire.

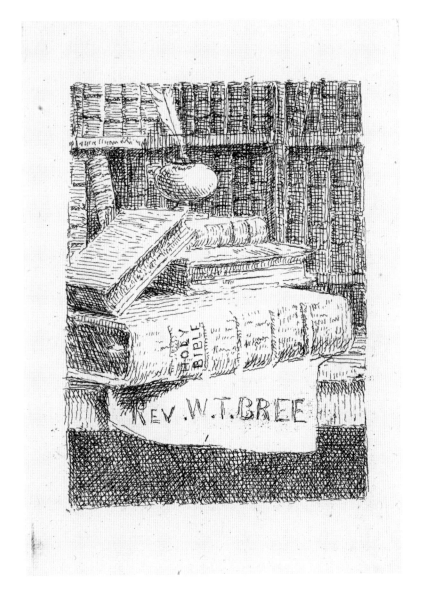

ALPHONSE
LEGROS
(1837–1911)
*Bookplate for
Léon Gambetta*
1875
Etching
12.4 × 8.5 cm

This print was
designed for the
French Republican
statesman Léon
Gambetta (1838–
82). The cockerel
of France is
depicted alongside
a declamatory
inscription
expressing
Gambetta's
ambition and two
hands pulling apart
a piece of wood,
symbolizing his
intention to break
the mould of French
politics. It was never
actually used as a
bookplate.

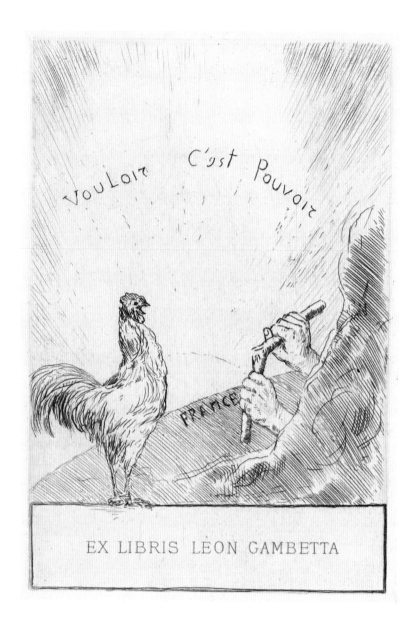

ALPHONSE
LEGROS
*Bookplate for*
*Guy Knowles*
Early 1880s
Etching and
drypoint
9.5 × 7.5 cm

Guy John Fenton
Knowles (1879–
1959) was the
young son of one
of Legros's most
important patrons,
the Russian-born
wool merchant and
hotel proprietor
Charles Julius Kino,
who changed his
name to Knowles
in the early
1880s. Legros was
renowned for his
series of etchings of
woodcutters.

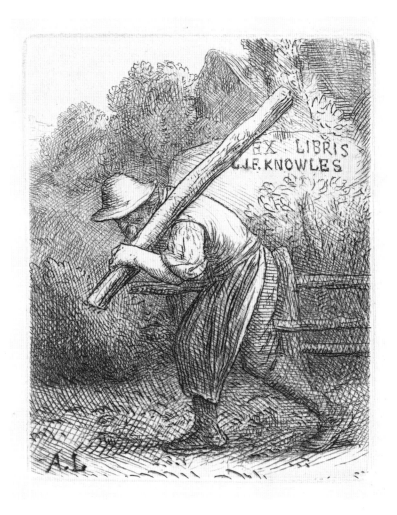

FÉLIX BUHOT
(1847–98)
*Le château des hiboux*
1877/87
Etching, drypoint
and aquatint
11.1 × 17.6 cm

Buhot originally made the right-hand side of this bookplate for the book dealer Léon Lerey, but it was not used. He returned to the print ten years later and added at the left the haunting nocturnal image of a castle behind many shining owls' eyes. Buhot, whose name in Spanish means owl, sometimes used the bird as his signature. There may well be a poetic source for this Symbolist image. The inscription in the foreground of Lerey's bookplate probably refers to a poem in Latin by the English romantic writer Walter Savage Landor.

GEORGE
CLAUSEN
(1852–1944)
*Bookplate for the artist*
1884
Etching
7.4 × 7.1 cm

The imagery in
this English artist's
earliest etching
expresses what
was to be a lifelong
engagement with
rural life.

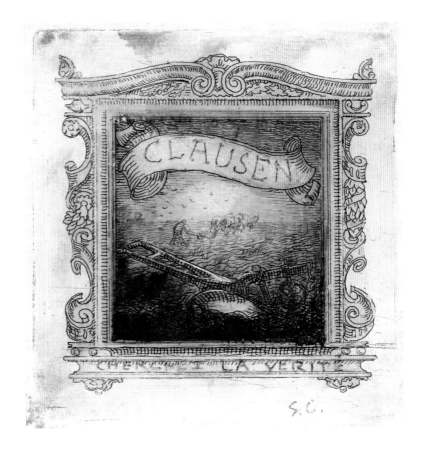

WILLIAM
HARCOURT
HOOPER
(1834–1912)
*Bookplate for
J.C. Brough*
*c.* 1870
Woodcut
6.2 × 5.7 cm

This bookplate was
made by Hooper
for his friend, the
popular science
writer John Cargill
Brough (1834–72).
The bird is a jay,
which makes the
pun 'jay sea be
rough'. The print is
a very early example
of a British work in
the Japoniste style.

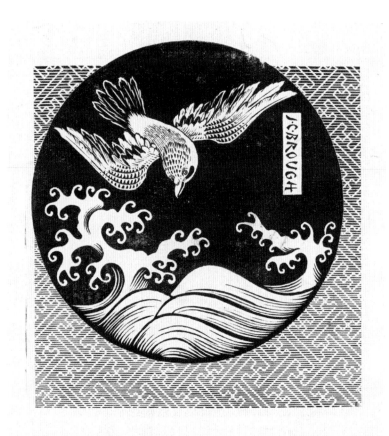

EDWARD
BURNE-JONES
(1833–98)
cut by William
Harcourt Hooper
*Bookplate for*
*Frances Horner*
Woodcut
8.7 × 6.5 cm

Edward Burne-
Jones designed
this bookplate for
Frances Horner
(1858–1940),
the daughter
of his patron
William Graham, a
Glasgow merchant
and member
of parliament.
The painter also
designed a piano
for Frances, which
was decorated with
similar cherubs.

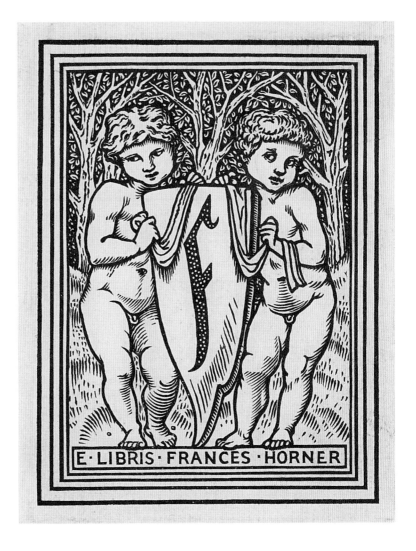

E·LIBRIS·FRANCES·HORNER

WILLIAM
HARCOURT
HOOPER
*Bookplate for Richard
Stamper Philpott*
1893
Hand-coloured
woodcut
7.8 × 5.2 cm

Hooper made this
bookplate from an ink
drawing given to him by
the illustrator Edmund
Hort New (1871–
1931). Philpott (1823–
94) was the Prebendary
of Wells and Rural
Dean of the Midsomer
Norton division of the
Frome Deanery. The
date 1884 probably
refers to the year that
Philpott bought the
house next door to
Kelmscott House,
William Morris's home
in Hammersmith,
shortly before he gave
up his position as Vicar
of Chewton Mendip and
Emborrow.

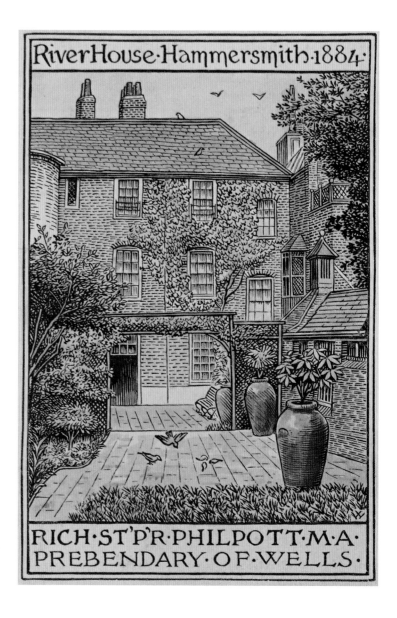

ROBERT
ANNING BELL
(1863–1933)
*Bookplate for Mander
Brothers' Workpeople's
Library*
*c.* 1894
Colour
photomechanical
process
13.6 × 10.9 cm

This was executed
after Bell's design
by Thomas
Matthews Hare
& Co., a firm of
wood engravers
long established
in London. The
plate was printed
with inks made by
Mander Brothers,
a Wolverhampton
varnish and
chemical company.
The library had
been started by the
firm in 1863.

ROBERT ANNING
BELL
*Design for a bookplate
for Frederic Leighton*
1894
Black ink and wash
16.4 × 12.3 cm

These two bookplates
were designed by Bell
for the leading artist
Frederic Leighton
(1830–96), who
became President of
the Royal Academy in
1878 and was the first
painter to be created
a Baron in 1896.
Bell paid tribute to
the classical style of
Leighton's paintings
and sculptures with
this Michelangelesque
image of a young man
reading. The design is
so close to Leighton's
own work that it is
likely the older artist
closely supervised its
execution.

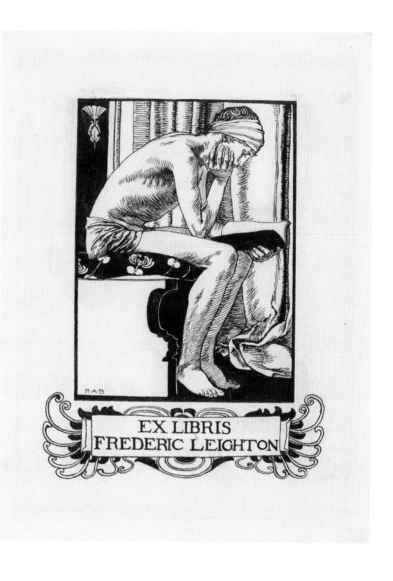

ROBERT ANNING
BELL
*Bookplate for*
*Frederic Leighton*
1894
Wood engraving
17.6 × 9.8 cm

The tree symbolizes
life and knowledge.
Each of the three
girls at left carries
a volume indicating
the source material
of Leighton's art.

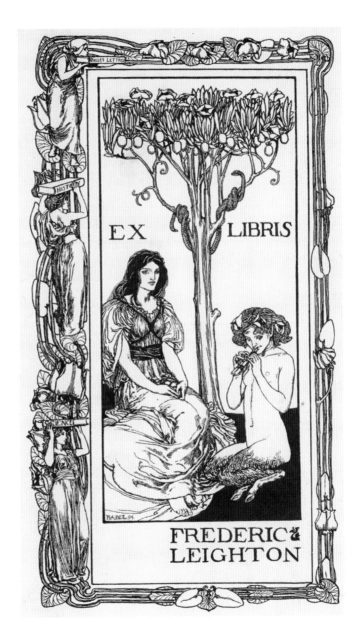

WILLIAM
RICHARD
LETHABY
(1857–1931)
*Bookplate for the*
*Architectural*
*Association*
1889
Lithograph
15.9 × 9.8 cm

The architect was
commissioned to
design this bookplate
in the first year of
the presidency of
Leonard Stokes,
who completely
reorganized the
Architectural
Association. The
design may have
represented a
concept for a new
entrance to the
library when the
Association moved
its London premises
in 1891 from
Conduit Street to
Great Marlborough
Street.

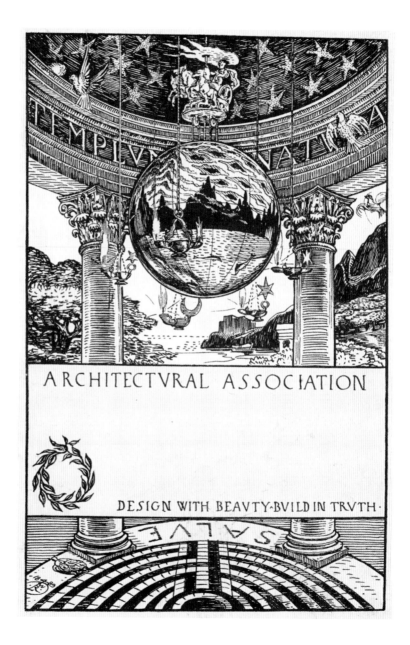

**ALTHEA GYLES**
(1860–1949)
*Bookplate for Lady Colin
Campbell*
*c.* 1895–9
Photogravure
8.9 × 7.9 cm

Lady Colin Campbell
(Gertrude Elizabeth
Blood; 1857–1911) was an
author, art and music critic,
journalist and socialite, and
a famous beauty. In 1886
she had been the subject of a
famous divorce case in which
she had the worst of the
suit, despite the character
of her husband, Lord Colin
Campbell, a notorious roué,
syphilitic and bully. This
print was executed by the
firm Walker & Boutall after
Gyles's design. Its imagery of
fawns and nymphs dancing
round an altar probably
reflects Gyles's interest
in the occult (she was a
member of the magical

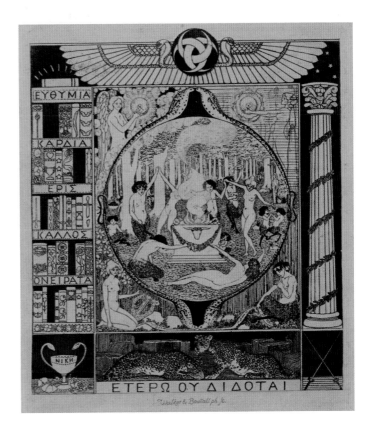

order The Golden Dawn, along with her friend W.B. Yeats).
The Greek inscription at the bottom, meaning 'not granted to
another', may allude to admission to the mysteries of a sect as
well as to Campbell's books, which are divided into thematic
categories by the inscriptions at the left: cheerfulness, the heart,
strife, beauty and dreamed things.

CHARLES ROBERT ASHBEE
(1863–1942)
*Bookplate for the artist*
*c.* 1889
Woodcut
6.5 × 3.4 cm

This print, an early work by the
leading Arts and Crafts architect
and designer C.R. Ashbee, is a
very good example of a punning
bookplate.

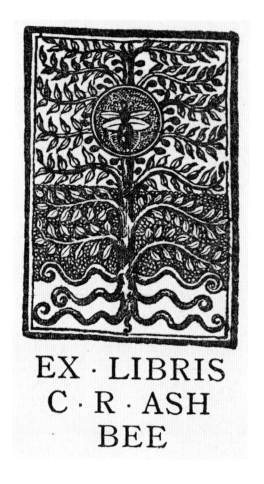

HEINRICH VOGELER
(1872–1942)
*Bookplate for Theodor Bienert*
1899, Etching and aquatint
14.5 × 9.8 cm

Theodor Bienert (1857–1935) was a mill owner who gave a hall of
residence to the Dresden Technical School in 1925. The bookplate
is punning, as 'bienert' means 'bee-like'. Vogeler used a millstone
to refer to Bienert's profession. In the far distance the dome of
Dresden's Frauenkirche can be seen.

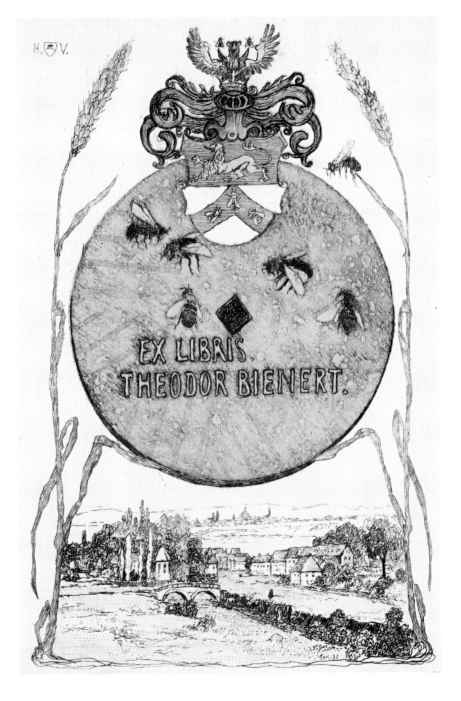

EX LIBRIS.
THEODOR BIENERT.

HENRY STACY
MARKS
(1829–98)
*A bit of blue and white*
1891
Wood engraving
16.1 × 10.5 cm

Marks made this
bookplate for
Frederick Litchfield
(1850–1930),
an authority on
antique furniture.
The two men shared
an enthusiasm
for oriental
ceramics. Marks
treated designs
for bookplates as
miniature pictures
drawn in pen and
ink, which he gave
to professional
wood engravers to
produce the finished
works.

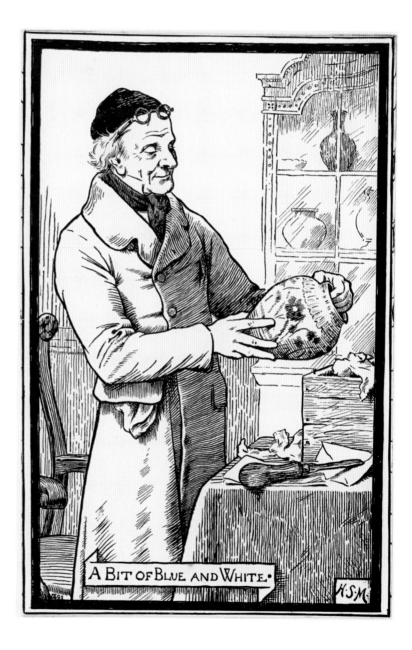

A BIT OF BLUE AND WHITE.

WALTER CRANE
(1845–1915)
*Design for a bookplate
for Mrs Ethel Alec
Tweedie*
1896 or earlier
Pen and black ink,
touched with white
18.1 × 11.9 cm

The patron (née
Ethel Brillana;
1867–1940)
was an amateur
watercolourist,
poetess, journalist
and well-known
travel writer, to
which activities
Crane's composition
refers. Crane
also incorporated
Tweedie's portrait
into his design
for the cover of a
booklet that she
edited, which was
sold at a bazaar in
aid of University
College Hospital,
London.

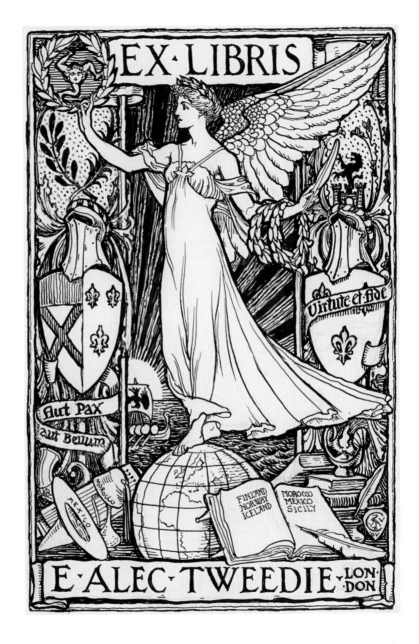

AUBREY
BEARDSLEY
(1872–98)
*Bookplate for John
Lumsden Propert*
1893
Line block
9.7 × 6.2 cm

John Lumsden Propert
(1835–1902) was
a doctor, writer on
miniatures and amateur
artist. The imagery of
this bookplate has not
been fully explained,
but Beardsley may
have been inspired by
the first verse of the
French nursery rhyme
*Au clair de la lune*: 'Au
*clair de la lune / Mon
ami Pierrot / Prête-moi
ta plume / Pour écrire
un mot / Ma chandelle
est morte / Je n'ai plus
de feu*' ('In moonlight
/ My friend Pierrot /
Lend me your pen /
To write a word / My
candle is dead / I have
no more fire').

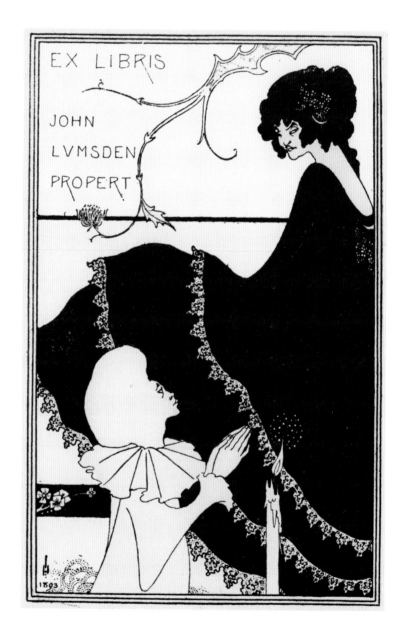

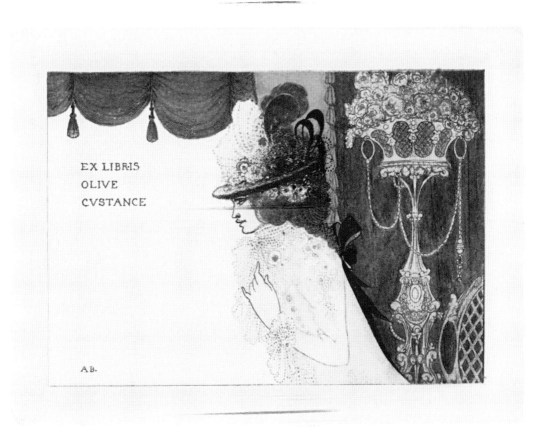

AUBREY BEARDSLEY
*Bookplate for Olive Custance*
1897
Photoengraving
7.7 × 10.5 cm

Olive Eleanor Custance (1872–1944) was a poetess and contributor to the quarterly literary periodical *The Yellow Book*, with which Beardsley was associated. She eloped with and married Oscar Wilde's former lover Lord Alfred Douglas. Her bookplate was commissioned by the publisher Leonard Smithers.

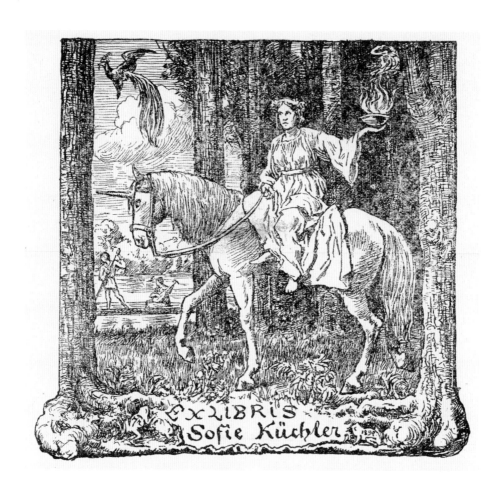

HANS THOMA
(1839–1924)
*Bookplate for
Sofie Küchler*
1894
Wood engraving
12 × 12.6 cm

This bookplate was made for the daughter of Eduard and Elise Küchler, who were major patrons of Thoma, owning twenty-seven paintings by him (the artist made another portrait of Sofie, in oils, in 1901). The unicorn has long been a symbol of chastity, while the torch carried by its rider is emblematic of truth and learning. The presence of the cock and the fact that the girl is on horseback suggest that the print was commissioned with reference to Sofie's eventual marriage.

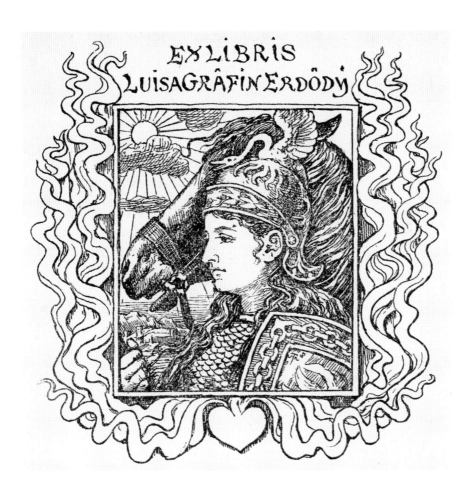

HANS THOMA
*Bookplate for Luisa, Gräfin Erdödy*
1885
Wood engraving
10 × 10.5 cm

The Gräfin owned several paintings by Thoma. She was the dedicatee of Wagner's *Wesendonck lieder* of 1857–8, hence the imagery of a Valkyrie.

JOHN DICKSON
BATTEN
(1860–1932)
*Bookplate for the artist*
13 January 1894
Colour woodcut
12.5 × 10 cm

The artist's initials
are woven into a
grapevine, a symbol
of abundance and
rebirth. As the first
British artist to use
Japanese methods in
making woodblock
prints, it is possible
that Batten was
proclaiming his
revival of the colour
woodcut.

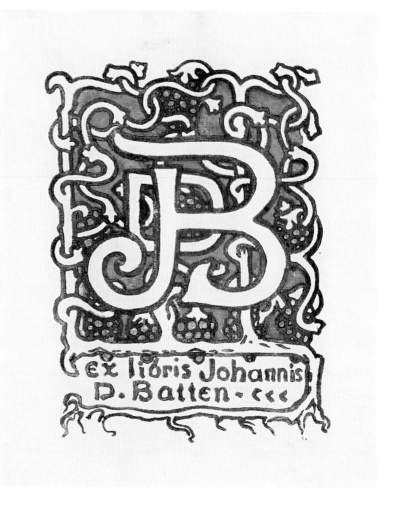

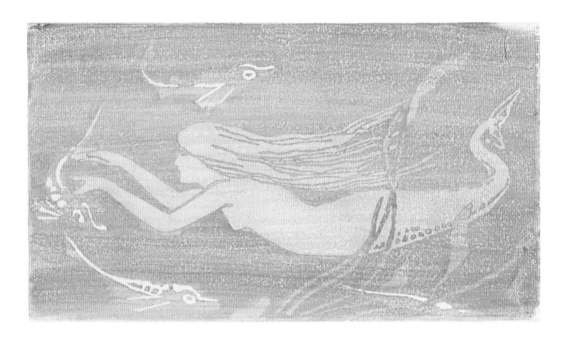

JOHN DICKSON BATTEN
*Mermaid bookplate*
10 April 1894
Colour woodcut
8.5 × 15.1 cm

Batten was assisted in the execution of this print by the neurologist and paediatrician Dr Frederick Eustace Batten (1865–1919), who cut the blocks after his relative's design. The bookplate may well have been intended for Frederick, as mermaids were reputed to teach humans cures for disease.

BERTHA BAGGE
(1859–1939)
*Bookplate for the artist*
1895
Etching
12.7 × 7.9 cm

Bertha Bagge
specialized in views
of her home town
of Frankfurt am
Main. She included
in the background of
her own bookplate
the Eschenheimer
Tower, an early
fifteenth-century
gate emblematic
of the city, which
still survives
from its medieval
fortifications.

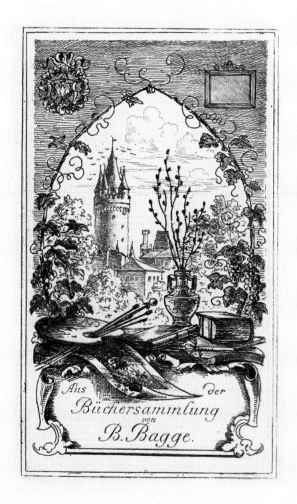

BERTHA BAGGE
*Bookplate for*
*Dr Heinrich Pallmann*
*c.* 1894
Etching
10.6 × 8.1 cm

The image of St Jerome in his study is appropriate for a scholar, but also has echoes of Goethe's *Faust*. The design is loosely related in reverse to a Dürer woodcut of 1511, while the ornamental framing refers to other early Northern prints by Israhel van Meckenem. Pallmann (1849–1922) published books about Goethe's house in Frankfurt, the city in which Pallmann was living at the time of the commission. He later became a curator in the Print Room in Munich.

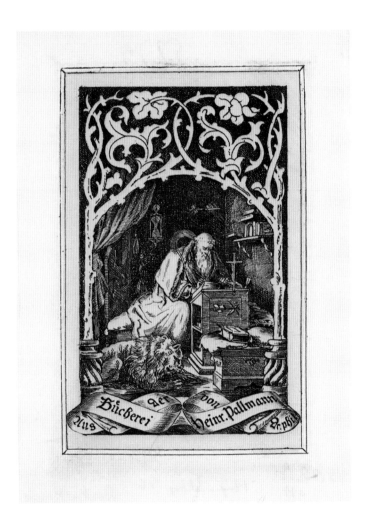

WILLIAM
NICHOLSON
(1872–1949)
*Bookplate for Phil May*
1895
Woodcut
9.9 × 9.7 cm

In this bookplate
the artist has chosen
to depict a coster
girl, one of the most
famous subjects of
the caricaturist Phil
May (1864–1903).

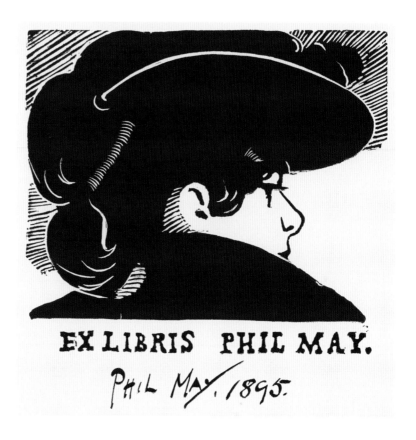

WILLIAM NICHOLSON
*Bookplate for W.E. Henley*
1900
Colour woodcut
7.2 × 7.2 cm

The poet, critic and editor
William Ernest Henley (1849–
1903), one of the artist's early
patrons, was famous for his
irascibility, stalwart patriotism
and short legs. Through this image
Nicholson hints at both Henley's
personality and the figure of John
Bull, the personification of an
Englishman.

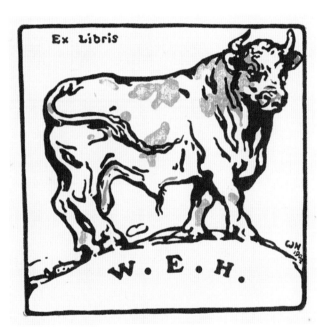

MAJOR ERNEST
BENGOUGH
RICKETTS
(b. 1842, d. ?)
*Bookplate for Sir Monier
Monier-Williams*
1897
Woodcut
10.8 × 6.3 cm

Sir Monier Monier-
Williams (1819–99)
was Professor of
Sanskrit at Oxford
University, where he
established the Indian
Institute in 1883, and
author of a famous
Sanskrit dictionary.
The imagery on this
bookplate includes
the Ashoka Chakra (a
twenty-four-spoked
wheel, the national
emblem of India),
lotus flowers, a
Mughal peacock and
a Hindu swastika.
The motto, *Dominus
illuminatio mea*, is that
of the University.

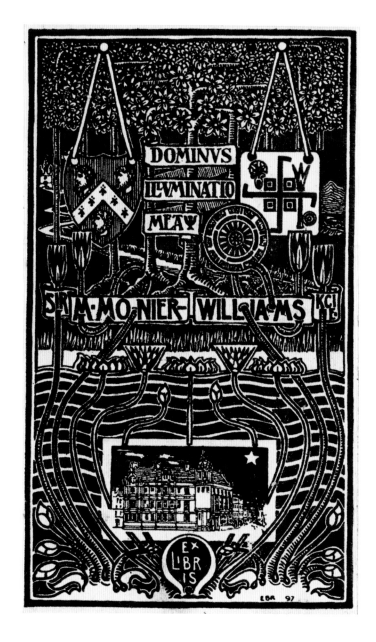

THEODORE
SPICER-SIMSON
(1871–1959)
*Bookplate for Ernest
Bengough Ricketts*
1897
Wood engraving
13.8 × 8 cm

Ricketts was a
mentor to the young
French-born artist
in Paris, and the two
men co-authored
the work *Composite
bookplates* of 1897–8.
Spicer-Simson later
settled in the United
States where he
became a notable
medallist.

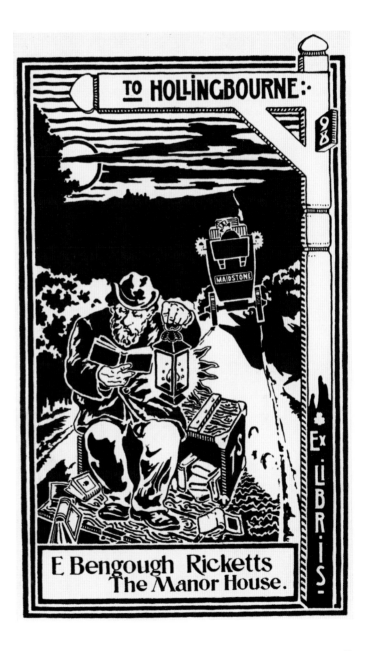

CYRIL GOLDIE
(1872–1942)
*Bookplate for Thomas
Edmund Harvey*
1897
Etching
13.9 × 10.2 cm

Harvey (1875–1955)
was a museum assistant
at the British Museum
from 1900 to 1904,
before becoming a
politician and social
reformer. He was
the second Warden
of Toynbee Hall and
served as the Liberal
member of parliament
for Leeds West from
1910 to 1918. Harvey
was a Quaker and a
pacifist, and it is likely
that this etching by a
Liverpool artist has
political meaning
alluding to the deaths
in the Boer War. The
hands holding rolls of
paper could refer to
disregarded petitions
against the war.

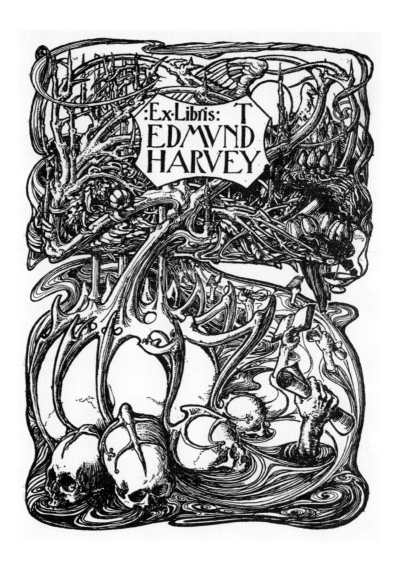

WILLIAM STRANG
(1859–1920)
*Bookplate for T. W. Dewar*
1898
Etching
10.7 × 7.5 cm

Dr Thomas William Dewar
of Dunblane (d. 1931) was
the author of a book on
the sanitation of armies in
the field, an expert on the
treatment of whooping
cough and tuberculosis,
and a donor to the Royal
College of Physicians of
Edinburgh. In the centre
of Strang's composition a
bishop with a crozier makes
a blessing; perhaps this is
Bishop Clement, who built
Dunblane Cathedral and was
later commemorated as a
saint but never canonized.
The Latin inscription means
'feeding the flame [of truth]
is a sweet solace for work'.

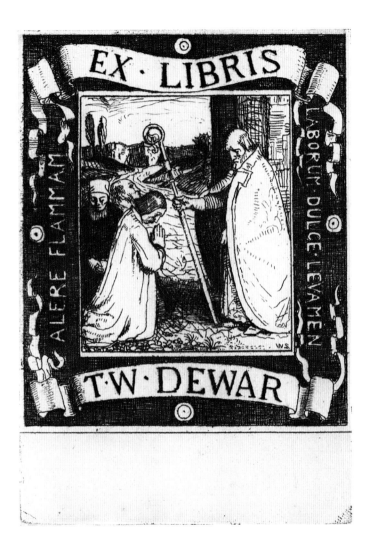

EMIL ORLIK
(1870–1932)
*Bookplate for Max Lehrs*
1899
Colour lithograph
10.8 × 9.2 cm

Max Lehrs (1855–1938)
was a renowned
historian of early
German printmaking
and twice Director
of the Dresden Print
Room. In 1892 he
published an essay on
the playing cards of the
goldsmith the Master
E.S. (active 1450–67),
one of the finest early
engravers, to whom
the letters in the globe
carried by the male
figure refer. Lehrs
eventually recorded all
the Master's engravings
in 1910.

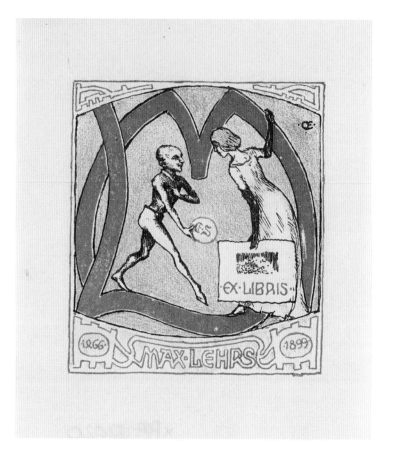

EMIL ORLIK
*Bookplate for Lilian*
*and Hans W. Singer*
*c.* 1898–1900
Lithograph
17.1 × 11 cm

This is one of two
bookplates that
Orlik made for Max
Lehrs's predecessor
as Director of the
Dresden Print
Room, Hans
Wolfgang Singer
(1867–1920). The
head of Minerva in
profile, based on
a classical Greek
source, refers to
learning. Singer
wrote scholarly
publications on
sixteenth-century
and contemporary
printmaking,
including an essay on
modern bookplates
and their designers in
1898, and a book on
Orlik's drawings in
1912.

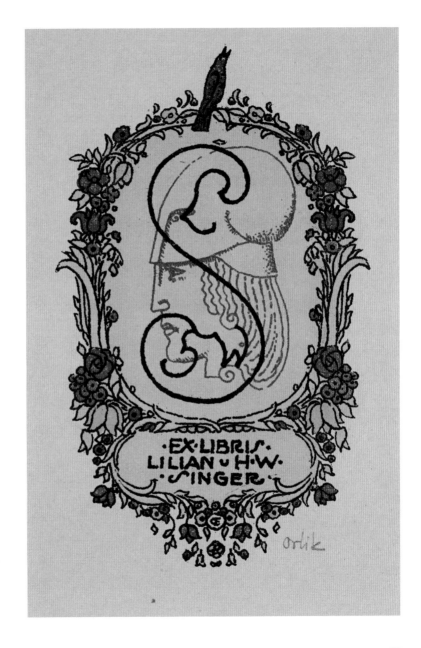

EDWARD
GORDON CRAIG
(1872–1966)
*Bookplate for*
*Ellen Terry*
1899
Woodcut
10.7 × 6.7 cm

This is the first
known bookplate
to represent a map.
It was made for
Craig's mother, the
actress Ellen Terry
(1847–1928), who
lived in the small
East Sussex town of
Winchelsea.

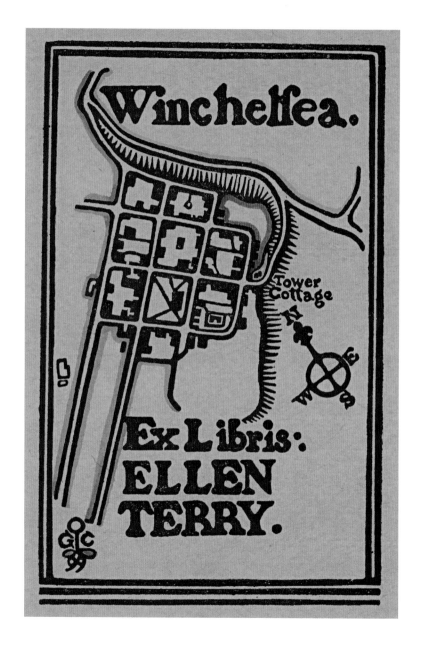

EDWARD GORDON CRAIG
*Bookplate for Kate (Kitty) Downing*
1900
Woodcut
5.6 × 4.7 cm

The kitten provides a punning
subject for this bookplate for the
wife of the antiquarian bookseller
and publisher William Downing
(1844–1910), who ran the Chaucer
Head Bookshop in Birmingham from
1870. William was a keen supporter
of the touring theatre company
Pilgrim Players, co-founded by
his son W.H. Downing, and a
correspondent of Craig's mother, the
actress Ellen Terry.

JOSEPH
SIMPSON
(1879–1939)
*Design for a bookplate*
c. 1898–1900
Pen and black ink
9.8 × 8 cm

As this print was
given to the British
Museum by Stewart
Dick, it is possible
that it is a portrait
of his wife, the
sculptor Dorothy
Dick. Stewart Dick
succeeded Simpson
in 1902 as the editor
of the Edinburgh
journal *The Book
of Bookplates*. The
prominent mimosa
may symbolize
youthful joy and
femininity. There
is no evidence that
the design was
ever turned into a
finished bookplate.

JOSEPH
SIMPSON
*Bookplate for Thomas
Nelson Foulis*
*c.* 1900–1
Woodcut
11.5 × 8 cm

The Edinburgh
publisher (*c.* 1874–
1943) commissioned
this print from his
fellow townsman,
and liked the image
so much that he
used it as the logo
of the firm that he
set up in 1903, T.N.
Foulis. Foulis also
employed Simpson
to design a typeface
and a series of book
covers in a chapbook
style. The cockerel is
a symbol of courage
and perseverance.

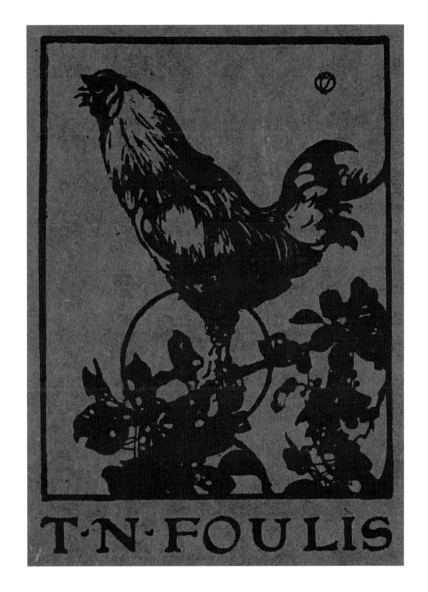

PAUL TÜROFF
(1873–before 1939)
*Bookplate for*
*Dr Georg Burckhard*
*c.* 1900–5
Etching and aquatint
13.6 × 8.6 cm

With this dramatic
image of St George
and the dragon, the
artist chose to refer
to the Christian
name of the owner
(1872–1955), a
medical practitioner.
The image of a
snake twisted
around a staff on the
shield at the right
refers to the Greek
god of medicine,
Aesculapius. The
owl, which can be
seen perched on a
book on the other
shield, is a symbol
of wisdom, and
is frequently, as
here, used to mark
a connection to
libraries.

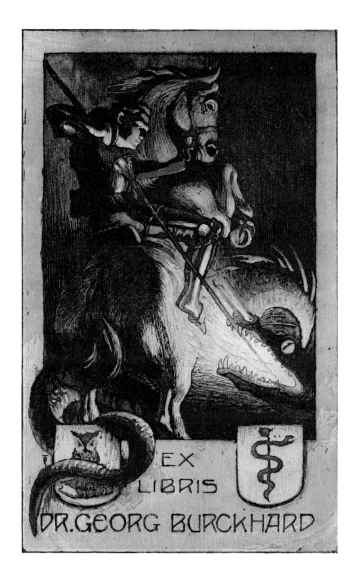

CHARLES
WILLIAM
SHERBORN
(1831–1912)
*Design for a bookplate*
*for William Bruce*
*Bannerman*
*c.* 1900
Pencil, ink and
white wash
16.7 × 9.7 cm

Bannerman
(1862–1933)
was a specialist
on heraldry and
published the
contents of many
parish registers.
Sherborn's designs
for bookplates were
much freer and
more vivid than his
finished engravings.

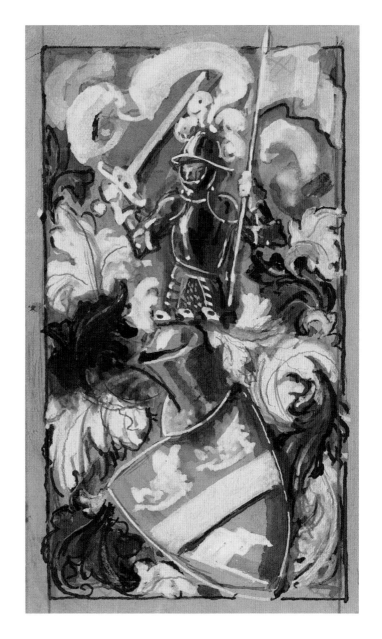

ALBERT WELTI
(1862–1912)
*Bookplate for Franz Rose of Doehlau*
1900
Etching
9 × 6.2 cm

Doehlau is a village north-east of
Bayreuth in Bavaria. The giant may be
a reference to the enormous bones
first discovered in 1535 by Berthold
Buchner in the Breitwinner caves
near Velberg, north of Regensburg in
Bavaria. In the foreground are roses,
referring to the book owner's surname.
Franz Rose (1854–1912) was born in
Schwerin on the Baltic and travelled
to Switzerland in the early 1890s. A
patron of young artists, he formed a
collection at Doehlau, where he also
planned a large English garden.

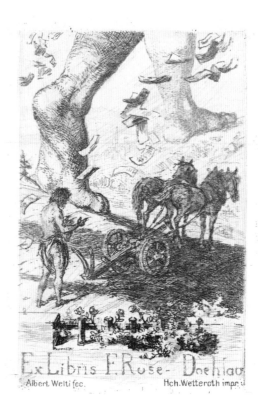

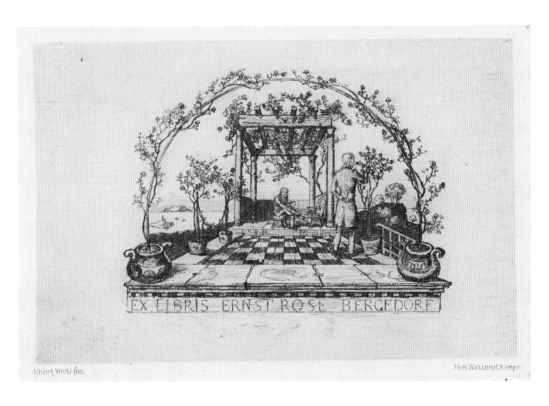

EX LIBRIS ERNST ROSE BERGEDORF

ALBERT WELTI
*Bookplate for Ernst Rose of Bergedorf*
1902
Etching
10.1 × 14.7 cm

The Swiss artist refers in a punning way to the surname of his patron through the image of an arbour adorned with roses. Bergedorf is a village close to Hamburg.

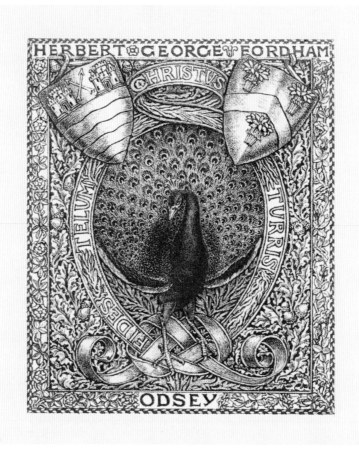

PHILIP WEBB
(1831–1915)
*Bookplate for Herbert George
Fordham of Odsey*
1901
Photoetching and engraving
10.2 × 8.9 cm

Sir Herbert George Fordham (1854–1929) of Odsey House in Guilden Morden, south Cambridgeshire, was a pioneer in cartography who gave his collection of maps and atlases to the Royal Geographical Society, the British Museum and Cambridge University Library. The motto in Latin expresses his deep adherence to the Christian faith, while the peacock is a Christian symbol of immortality, associated with the resurrection of Christ.

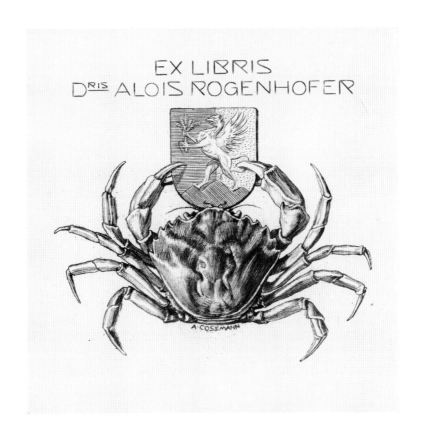

ALFRED COSSMANN
(1870–1951)
*Bookplate for*
*Alois Rogenhofer*
1910
Etching and engraving
8.7 × 8.4 cm

Dr Alois Rogenhofer (b. 1878, d. ?) was a librarian at the
University of Vienna who published articles on crustacea, hence
the choice of the crab.

HENRY
MACBETH-
RAEBURN
(1860–1947)
*Bookplate for*
*Basil Lewis Dighton*
Etching
13.8 × 8 cm

Basil Lewis Dighton
(died *c.* 1929), who
lived at no. 3 Savile
Row in London, was
an antique dealer
and authority on
sporting prints and
French eighteenth-
century line
engravings.

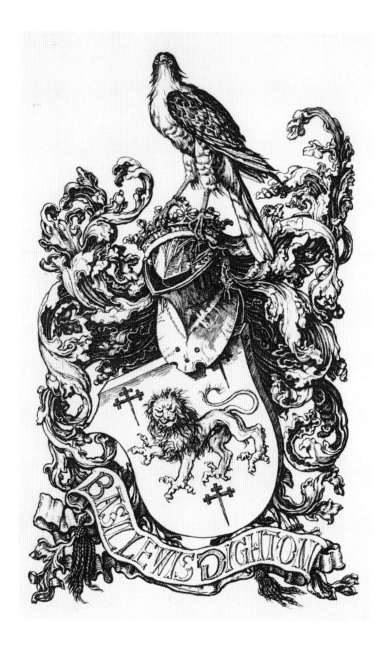

CONSTANCE MARY
POTT
(1862–1930)
*Bookplate for Ironmongers' Hall*
1904
Engraving
14.5 × 10.4 cm

Established in the fourteenth
century as the Company
of Ferroners, this City of
London livery company
revived interest in
blacksmithing by holding a
series of exhibitions from
1889. The Ironmongers'
crest includes a number of
iron and steel objects and
two supporting salamanders,
represented here. These
legendary lizards were
reputed to survive fire. The
ostriches symbolize the
rebirth of metals in a different
form after being cast in the
forge. The company uses a
Norman French motto '*Assaer
dure*', 'to test if it is hard'. The
saint is Lawrence, the patron
saint of the Ironmongers'
Company, with his attribute
of a grill.

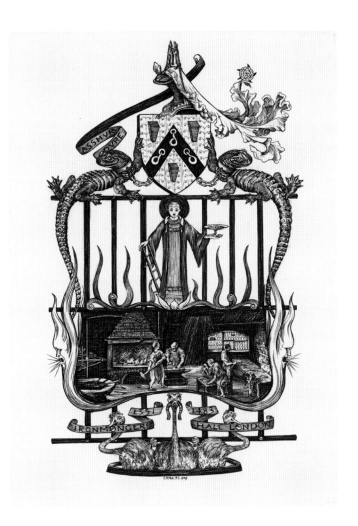

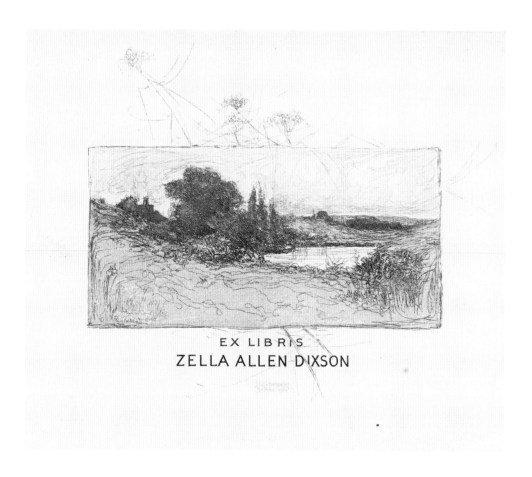

EX LIBRIS
ZELLA ALLEN DIXSON

JOSEPH WINFRED
SPENCELEY
(1866–1908)
*Bookplate for Zella Allen Dixson*
1905
Photomechanical
reproduction of an etching
7.1 × 8.3 cm

Zella Allen Dixson (1858–1924) was a teacher of library science and the de facto head of the University of Chicago Library from 1891 to 1910. She ran the Wisteria Cottage Press in Chicago, publishing three works on bookplates. The water visible in this print may be the Lazy River in Granville, Ohio, where Dixson stayed at Wisteria Cottage during the summer. The long-stemmed flowers that stray outside the bounds of the image may be dandelions, symbolizing the transitory nature of human life.

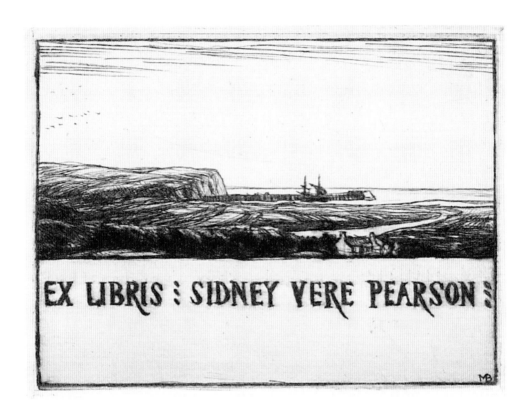

MUIRHEAD BONE
(1876–1953)
*Bookplate for*
*Sidney Vere Pearson*
1908
Drypoint
5.2 × 7.1 cm

This bookplate shows the cliffs of the Norfolk coast near Cromer, close to Mundesley, where Pearson (1874/5–1950) was Warden of the Mundesley Sanatorium from 1905. Members of Pearson's family were long-time friends of the artist. His brother, W. W. Pearson, had staged Bone's first one-man exhibition in his rooms at Emmanuel College, Cambridge. Sidney Pearson purchased an etching at the exhibition, which is now in the collection of the British Museum.

EX LIBRIS
AUG·F·
AMMANN

OTTO
UBBELOHDE
(1867–1922)

*Bookplate for August
Ferdinand Ammann*

1906

Etching, 23 × 14 cm

Illustrated here are two of three bookplates executed by the German printmaker Ubbelohde for August Julius Ferdinand Ammann (1850–1924), a collector of *ex libris*. The imagery relates to a book published by his ancestor Hans Jakob Ammann in 1630, *Reise in Gelobte Land* (*Travels in the promised land*), of which August owned an edition. The Swiss flag on the ship denotes his nationality. August published a book on the history of his noble Zürich family in 1904.

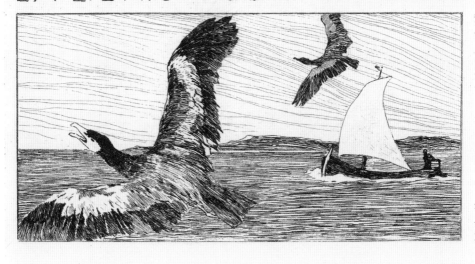

OTTO UBBELOHDE

*Bookplate for August Ammann*

1906

Etching, 8.5 × 12.8 cm

August Ammann lived at Renens sur Roche, a suburb of Lausanne on Lake Geneva, of which he probably had a view from his house. The ducks or geese are Celtic symbols of honesty and resourcefulness.

MAX KLINGER
(1857–1920)
*Bookplate for Professor Dr Richard Graul*
1906
Etching
13.3 × 9 cm

Richard Graul (1862–1944), a prolific writer on European and Asiatic art-historical subjects, was Director of the Leipzig Museum of Arts and Crafts from 1896 to 1929, and joint editor of the journal *Das Museum*. It is possible that the image of a naked woman riding a dolphin, drawn in an orientalizing style, referred to the publication in 1906 of Graul's book *Ostasiatische Kunst und ihr Einfluss auf Europa*. A ceramic dolphin tripod was illustrated in the volume *Althüringer Porzellan*, which Graul published in 1909 with Albrecht Kurzwelly.

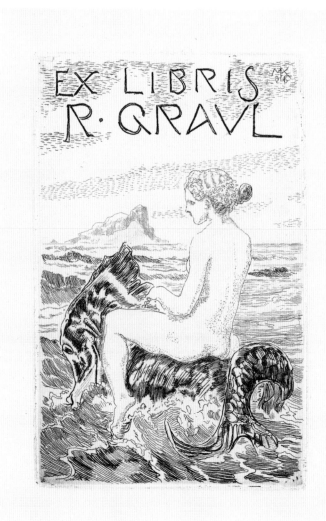

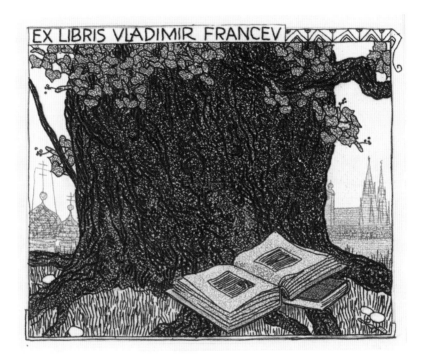

EX LIBRIS VLADIMIR FRANCEV

VOYTECH PREISSIG
(1873–1944)
*Bookplate for*
*Vladimir Francev*
1909
Etching
7.9 × 9.5 cm

Vladimir Francev (1867–1942) was a Professor at universities in Warsaw and Prague who wrote on Czech literature and the work of Pushkin and Gogol. The Roman Catholic Cathedral of St Vitus in Prague can be glimpsed behind the tree on the right, while the onion domes of the Russian Orthodox Church of St Mary Magdalene in the Praga district of Warsaw are visible at the left.

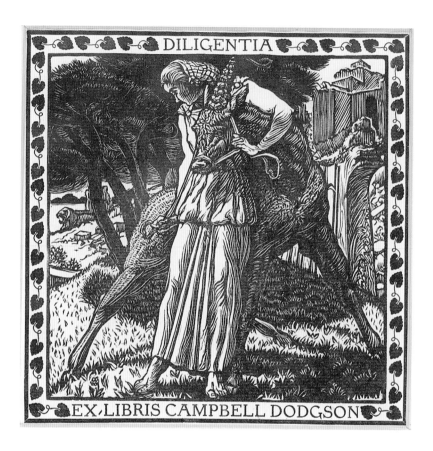

THOMAS
STURGE
MOORE
(1870–1944)
*Bookplate for*
*Campbell Dodgson*
1909
Wood engraving
9.9 × 9.9 cm

Campbell Dodgson (1867–1948) joined the staff of the British Museum's Department of Prints and Drawings in 1893, and served as its Keeper from 1912 to 1932. During his time there he was responsible for considerably enhancing the Museum's collection of bookplates. It is likely that the unicorn was chosen by Dodgson, as it also appears in another bookplate made for him by the Australian artist Lionel Lindsay. Reputed to be tireless, it is also regarded as the noblest of animals. The publisher of three of Moore's books was called At the Sign of the Unicorn, and Dodgson assisted Moore on one of these volumes, about the German painter Altdorfer.

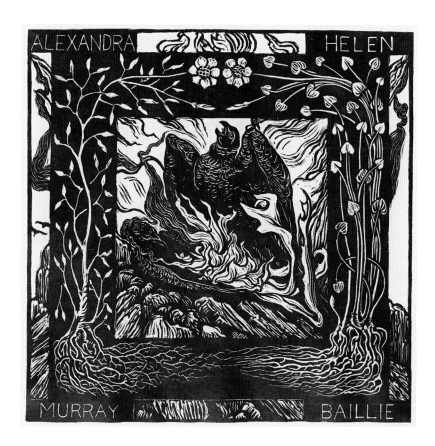

THOMAS
STURGE
MOORE
*Bookplate for*
*Alexandra Helen*
*Murray Baillie*
1914
Wood engraving
10 × 10 cm

Alexandra Murray Baillie (née Cavan Irwing; d. 1946), of the Broughton and Cally estates near Gatehouse of Fleet in Galloway, was the wife of Lieutenant Colonel Frederick Murray Baillie, a copper miner and landowner. The couple moved to Gargano on Lake Garda in northern Italy. The plants on the frame of Alexandra's bookplate are inspired by the writings of the Italian poet Gabriele D'Annunzio, who lived on Lake Garda. The phoenix is a symbol of immortality and the resurrection.

THOMAS STURGE MOORE
*Bookplate for George Yeats*
1918
Wood engraving
12 × 8.3 cm

George Hyde Lees Yeats (1892–
1968) and her husband, the
poet W.B. Yeats, were members
of the Order of the Golden
Dawn, a society devoted to
magical and spiritual matters.
The unicorn is a symbol of
arcane knowledge before the
Flood, and also serves here
as both George's soul and
her daimon. The tower could
have associations with the
sixteenth-century Thor Ballylee
in County Galway, which W.B.
Yeats bought in June 1917 and
restored for his wife, and with
the Lighthouse of Alexandria,
the city in which so many
hermetic texts originated. The
zigzag is the lightning flash that
emanated from and returned
to the tree of life. The hawk
is a symbol of the sun and of
the human soul, here perhaps
representing the soul of the
poet.

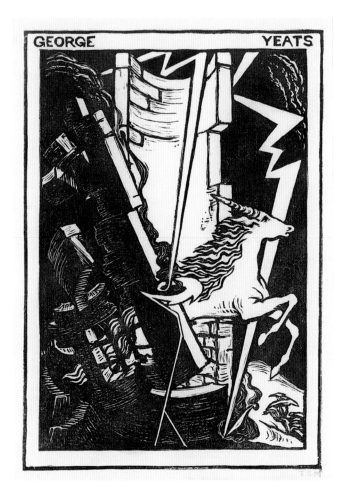

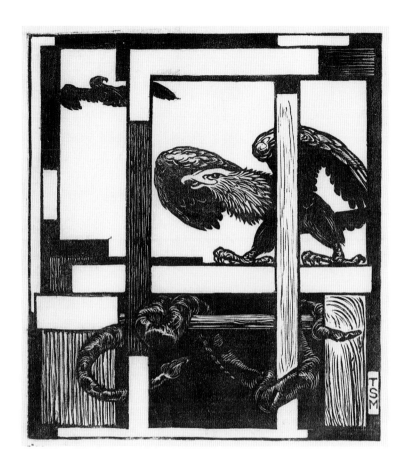

THOMAS
STURGE MOORE
*Bookplate for
W.S. Kennedy*
1920
Wood engraving
10.5 × 9.4 cm

The literary critic and translator William Sloane Kennedy (1850–1929) was a close associate of Walt Whitman and wrote about Emerson, Longfellow, Whittier and Oliver Wendell Holmes. As the author of *Poems of the Weird and Mystical*, it is appropriate that the imagery of his bookplate is esoteric. As well as referring to Kennedy's American citizenship, the combination of an eagle and a snake may symbolize a balance between the spiritual and the intellectual.

GEORGE
WILLIAM EVE
(1855–1914)
*Design for a bookplate*
*for Mary Rose*
*Barrington*
*c.* 1911
Pencil
11.6 × 8.6 cm

It is possible that the
galleon represents
Henry VIII's famous
warship the *Mary
Rose*, built between
1509 and 1511,
which sank off the
coast of Portsmouth
in 1545, was raised
from the seabed in
1982 and can now
be visited in the
historic dockyard
there. A decoration
of roses frames the
oval image of the
ship.

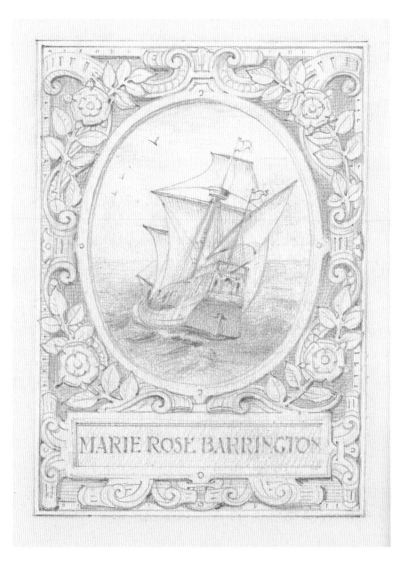

THOMAS
W. NASON
(1889–1971)
*Bookplate for*
*John Taylor Arms*
1937
Etching
10.1 × 7.6 cm

John Taylor Arms
(1887–1953), the
leading architectural
etcher in America
at the time,
encouraged Nason
to take up etching
in 1933. The image
may refer to Arms's
voyages to Europe
to etch cathedrals.

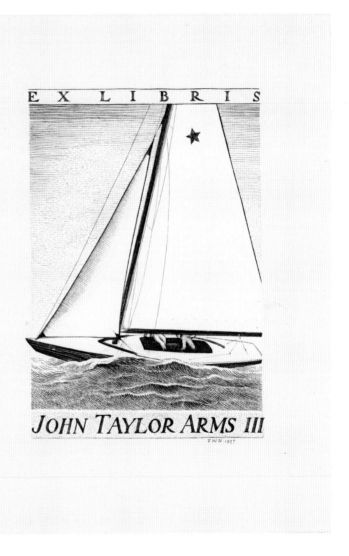

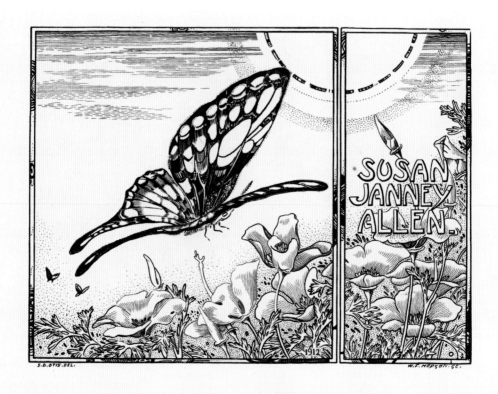

WILLIAM FOWLER
HOPSON
(1849–1935)
*Bookplate for Susan Janney
Allen*
1912
Engraving, 6.6 × 8.6 cm

Susan Janney Allen lived at Moorestown, New Jersey, and was a member of the Ex Libris Society from 1913. She may have been the author of a one-act children's play, *The East Wind's revenge*, published in New York around 1924. Hopson based this print on a drawing by Samuel Davis Otis (1889–1961).

KATHERINE
CAMERON
(1874–1965)
*Bookplate for*
*Arthur Kay*
1914
Etching
11.1 × 7.5 cm

Katherine Cameron
was famous for her
etchings of insects.
This is one of several
bookplates that
she made for her
husband, the art
collector Arthur Kay
(1861–1939). The
butterfly wings may
represent Kay's soul.

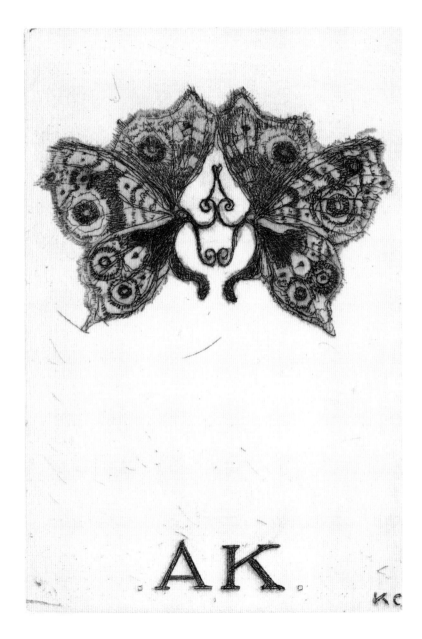

ERIC GILL
(1862–1940)
*Pegasus*
1912
Wood engraving
8.1 × 6.4 cm

This bookplate
was made for the
poet, typographer
and founder of
the Pelican and
Nonesuch Presses,
Sir Francis Meynell
(1891–1975).
Pegasus, the
winged horse of
classical mythology,
was a symbol of
poetic inspiration.
Meynell reused
the block, without
the inscription, as
the frontispiece of
his *Fifteen Poems*,
published by the
Fanfare Press,
London, in 1944.

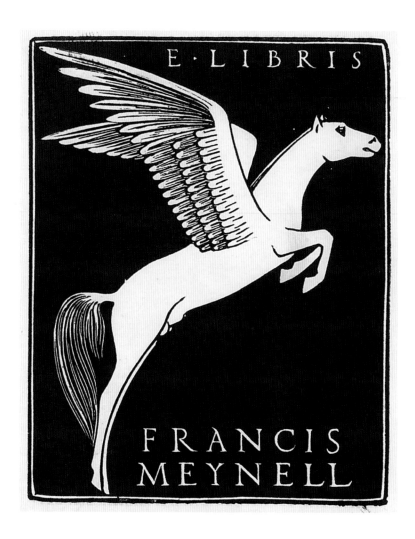

ERIC GILL
*Bookplate for Ananda*
*Kentish Coomaraswamy*
1920
Wood engraving
6 × 6.2 cm

The Tamil
philosopher,
historian and art
historian Ananda
Coomaraswamy
(1877–1947) was
an outstanding
writer on Indian,
Persian and Mughal
culture. This
bookplate shows
Sita embracing
the golden deer, a
subject taken from
the Hindu epic the
*Ramayama*.

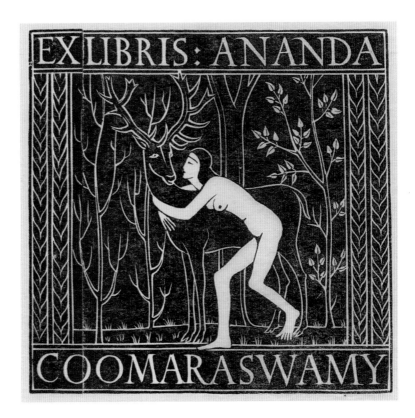

ALEJANDRO DE
RIQUER
(1856–1921)
*Bookplate for Anton
Dalmáu i Jambrú*
1913
Etching
19.3 × 12.4 cm

De Riquer, the
outstanding Catalan
bookplate artist of
the day, made this
print for a compatriot
whose family ran a
publishing house in
Barcelona and Gerona.
Two girls are set
against a distant view
of the unusual rock
formations behind
the Benedictine
abbey of Santa Maria
de Montserrat, the
spiritual symbol of
Catalonia, in the
Pyrenees.

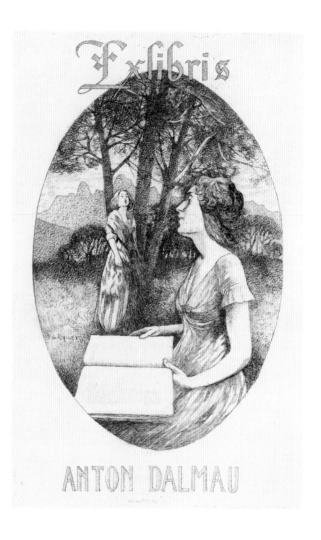

**ALEJANDRO DE RIQUER**
*Bookplate for Eduard de Toda*
1913
Etching
19.8 × 16.2 cm

The diplomat, archaeologist and Egyptologist Eduard de Toda y Guell (1855–1941) came from Reus, the second city of Catalonia. He assembled a huge library, which he gave to various institutions in the region. The inscription on the book depicted within the globe proclaims his belief that books provide enlightenment.

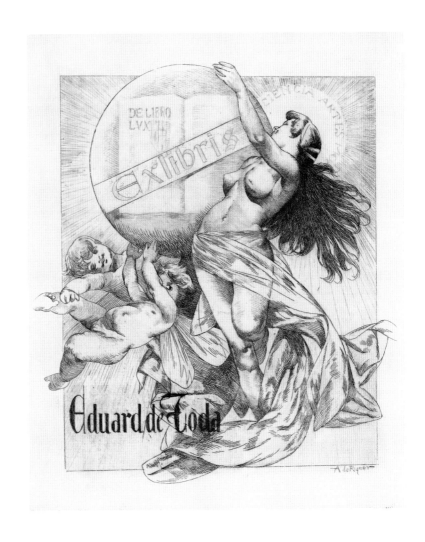

RUDYARD KIPLING
(1865–1936)
*Bookplate for Huntington
and Dorothy Babcock*
1915
Ink, 10.3 × 7.9 cm

Dorothy Doubleday
(b. 1893, still alive
1961) was the daughter
of Kipling's New York
publisher, Frank Nelson
Doubleday. The novelist
made the first design
of this astrological
bookplate for her
before she became
engaged to Huntington
Babcock (*c.* 1889–1973)
in 1914. When she
married, Kipling
altered the names on his
composition and made
this second version when
on board the SS *Lusitania*
with the young couple.
The two globes refer to
Dorothy's maiden name.
The significance of the
signs of the zodiac is yet
to be determined.

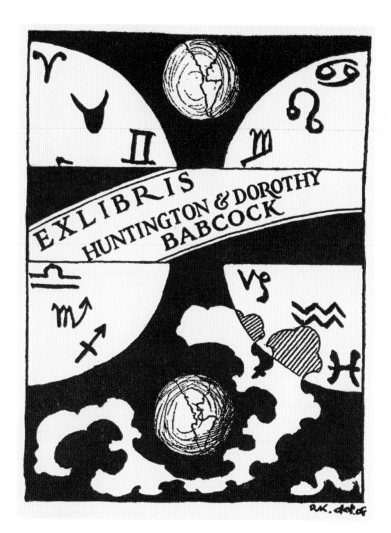

CHARLES FRANCIS
ANNESLEY VOYSEY
(1857–1941)
*Bookplate for*
*Harold Speed*
*c.* 1916
Woodcut
6.7 × 4.6 cm

The painter Harold Speed
(1872–1957) was a long-time
friend of the architect Charles
Voysey, and had made portraits
of him in 1896 and 1905. Both
men were members of the
Art Workers' Guild, which
held a meeting devoted to
the subject of bookplates on
7 July 1916, during Speed's
Mastership. This punning print
may well have been designed
at that time.

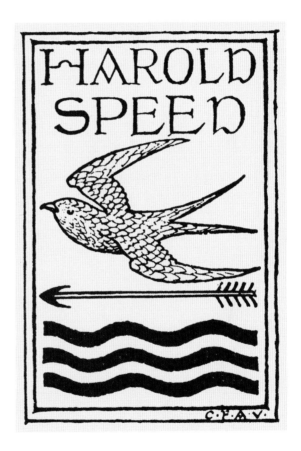

FERDINAND
SCHMUTZER
(1870–1928)
*Bookplate for*
*Albert Heine*
*c*. 1913
Colour etching
5.9 × 5.8 cm

Albert Heine
(1867–1949) was
director of the
Burgtheater in
Vienna and taught
at the Akademie
für Musik und
darstellende Kunst.
This portrait shows
him with some of
his working tools.

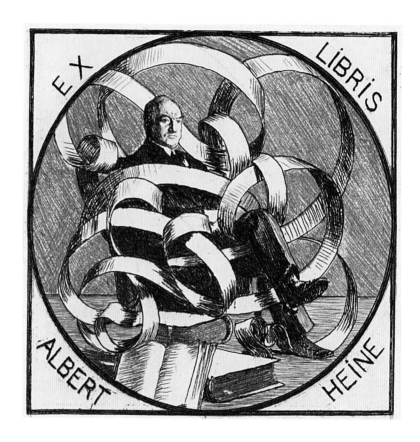

FERDINAND
SCHMUTZER
*Bookplate for*
*Julius Gustav Licht*
1919
Photogravure
7.2 × 7 cm

Licht may be the
Austrian Consul
General in Berlin.
The image updates
Dürer's famous
1513 engraving *The
Knight, Death and the
Devil*. The knight is
a Christian riding
fearlessly along the
thorny path of life.

FERDINAND
SCHMUTZER
*Bookplate for Professor
Dr Siegfried Gross*
1916
Etching
13.5 × 9.1 cm

Gross (usually
spelled Grosz;
1869–1922)
lectured on
dermatology and
syphilology at
the University of
Vienna. In 1913
he co-authored
a monograph on
secondary sexual
characteristics with
Julius Tandler.

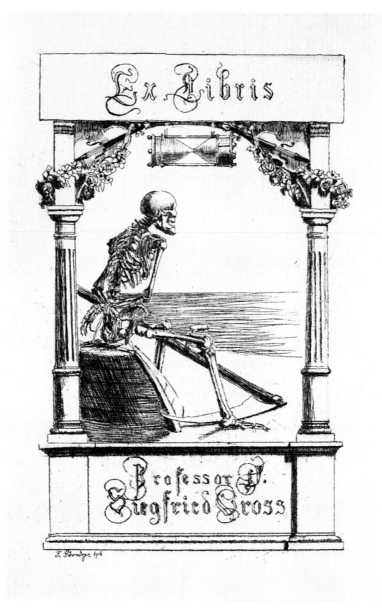

FERDINAND
SCHMUTZER
*Bookplate for
Julius Tandler*
*c.* 1919
Photogravure
16 × 8.2 cm

Julius Tandler
(1869–1936) was a
Viennese Professor
of Anatomy and
Social Democrat
politician. The
torches symbolize
life (pointing up)
and death (pointing
down).

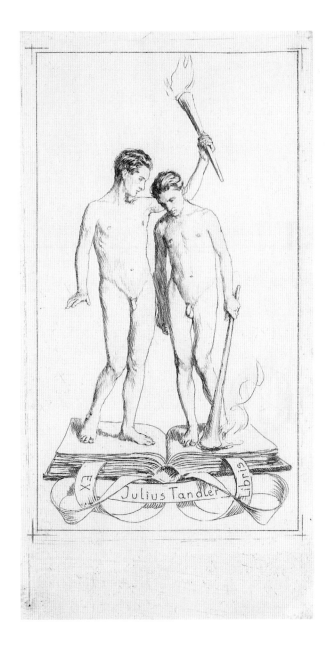

FERDINAND
SCHMUTZER
*Bookplate for
Marie Mautner*
1905
Etching
9 × 6.1 cm

The ghost of
Shakespeare
interrupts the
thoughts of the
painter and poet
Marie Mautner
(1886–1972) as
she sits at her desk,
in a composition
indebted to
the etchings of
Rembrandt.

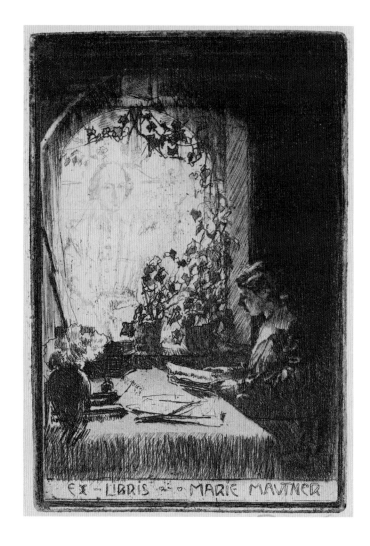

FERDINAND
SCHMUTZER
*Bookplate for*
*Flora Berl*
1917
Etching
12.4 × 8.7 cm

Flora Berl was the
wife of Oscar Berl,
an official at the
Austrian Court.
The family may
have originated
in Budapest. The
stag with a cross
between its antlers
is a symbol of St
Eustace, patron saint
of hunters.

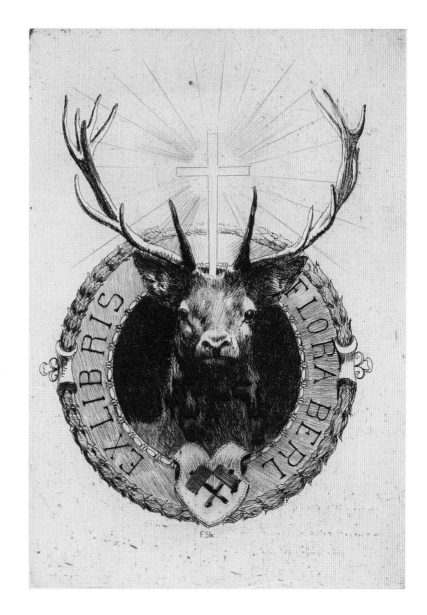

FREDERICK
GARRISON HALL
(1879–1946)
*Bookplate for William
McGregor Paxton*
1918
Wood engraving
12.4 × 8.7 cm

The Boston
painter Paxton
(1869–1941) is
shown at work on
his mural *The Navy
panel*, made for the
dining room of the
Army and Navy
Club in Washington
and installed there
in 1914. The
finished painting
combined both the
top and bottom
compositions as a
single frieze. Hall
has changed the
position of some of
the figures to make
the composition
more appropriate
for his bookplate.

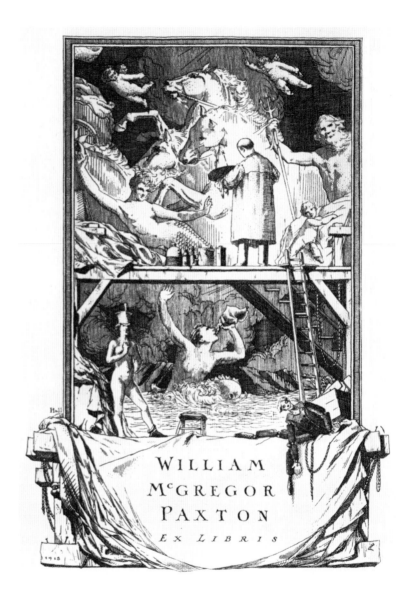

WILLIAM
McGREGOR
PAXTON
EX LIBRIS

FRANK WESTON
BENSON
(1862–1951)
*Bookplate for Charles
Martin Loeffler*
1918
Etching
21.5 × 12.4 cm

The American
composer, violinist
and Director of the
Boston Symphony
Orchestra (1861–
1935) was a long-
time friend of the
artist. Both men
were members of
the Tavern Club
in Boston and, on
Loeffler's death,
Benson delivered
an address there
in tribute to him.
An eagle in flight
is a symbol to
Americans of
strength, endurance
and vision.

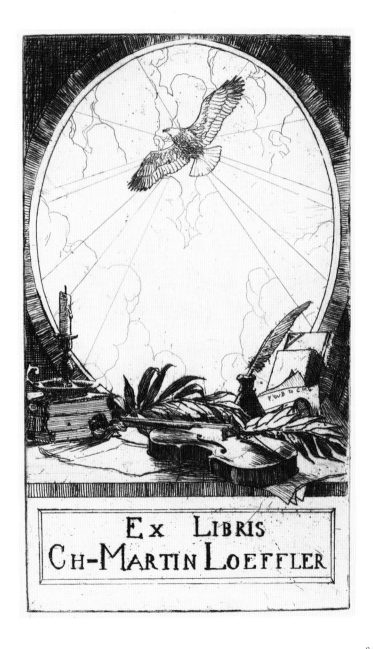

EX LIBRIS
CH-MARTIN LOEFFLER

SIGMUND
LIPINSKY
(1873–1940)
*Bookplate for M.Wirth*
1918
Etching and
engraving
17.4 × 9.5 cm

Lipinsky made seven
bookplates for this
family of Munich
businessmen, five of
them in connection
with a wedding
that took place on
7 August 1918.
The nude woman
represents Fortune,
who is often
shown with a sail.
She stands on the
helmeted head of
Hermes, messenger
of the gods.

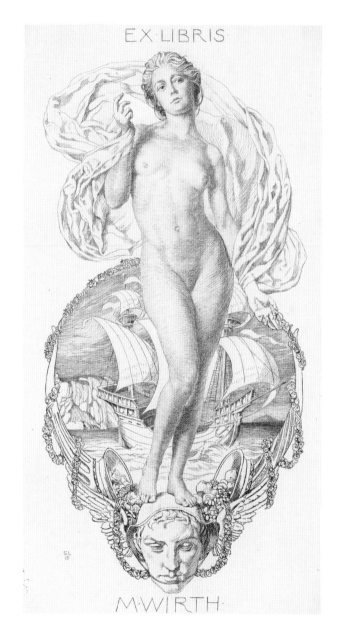

SIGMUND
LIPINSKY
*Bookplate for*
*Adolf Wilhelm*
1921
Etching
12.4 × 6.1 cm

This bookplate may
be for the scholar
Adolf Wilhelm
(1864–1950), an
expert on Greek
inscriptions. Orange
trees are associated
with love and
marriage.

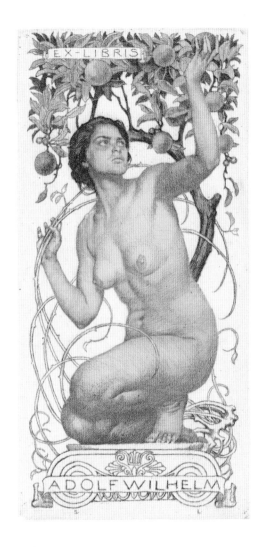

FRANK BRANGWYN
(1867–1956)
cut by Yoshijiro Urushibara or
Mokuko (1889–1953)
*Bookplate for Charles Holme*
*c.* 1918–19
Colour woodcut
12.6 × 6.4 cm

Charles Holme (1848–1923)
was the founding editor of *The
Studio*, a journal that frequently
published articles about
Brangwyn and illustrations
of his work. The plate may
be punning, 'holm' being a
word used in the English West
Country for 'small island'. The
heron was one of the attributes
of Athena, the Greek goddess
of wisdom. Urushibara came to
England in 1910 and frequently
collaborated with Brangwyn
in the early 1920s, executing
colour watercolours after the
British artist's designs. Holme
had visited Japan in 1889 and,
with his business partner, the
designer Christopher Dresser,
did much to disseminate
knowledge about Japanese arts
and crafts.

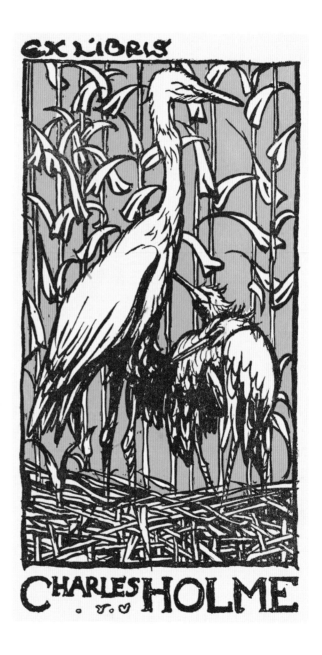

FRANK
BRANGWYN
*Bookplate for*
*A.B.C.D.E.*
1923
Chiaroscuro
woodcut
13.7 × 9 cm

This image of a
tattered travelling
salesman of second-
hand books was
made for the
Association Belge
des Collectionneurs
et Dessinateurs
d'Ex-libris, a
society founded in
1919, for which
Brangwyn, who was
born in Belgium,
designed several
bookplates.

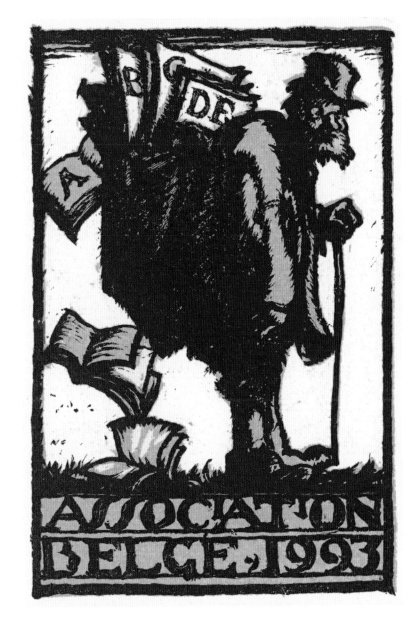

FRANZ VON BAYROS
(1866–1924)
*Bookplate for*
*Stefan Kellner*
*c.* 1915–20
Soft-ground etching
10.4 × 7.2 cm

Stefan Kellner was a
Hungarian print and book
dealer and publisher who
specialized in erotica
and maintained shops in
Vienna between 1925
and 1927. He was also
the editor of a book
about bookplates, *Exlibris*
*und Gelegenheitsgraphik*,
published in Budapest
in 1921. This is one of
seven bookplates made
for Kellner by Von Bayros,
who specialized in erotic
bookplates.

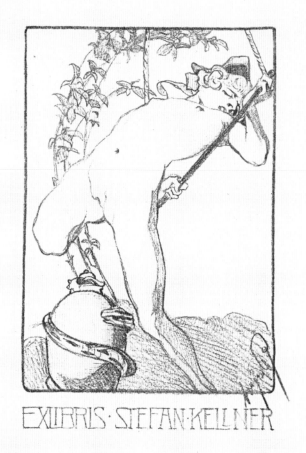

ALBERT
RUTHERSTON
(1881–1953)
*Bookplate for*
*H.C. Coleman*
1926
Colour lithograph
15 × 9.8 cm

Herbert Charles
Coleman (d. 1948)
was a Manchester
shipping merchant
of German origin,
and one of the most
significant early
collectors in Britain
of Impressionist and
Post-Impressionist
paintings. Albert
Rutherston was
the uncle of Oliver
Simon of the
Curwen Press in
Plaistow, where
this bookplate was
printed, and the
Press's first designer.

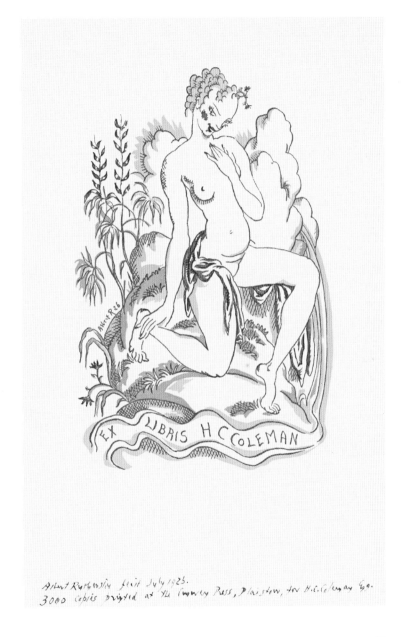

PAUL NASH
(1889–1946)
*Bookplate for Bunty*
1919
Wood engraving
5.1 × 3.2 cm

Bunty was the nickname of
Nash's wife, Margaret
(*c.* 1887–1960). The image
was partly inspired by her
husband seeing 'her hand in
its neat kid glove running
down the banister rail like a
little black mouse'. He was
also accustomed to calling her
'dove'.

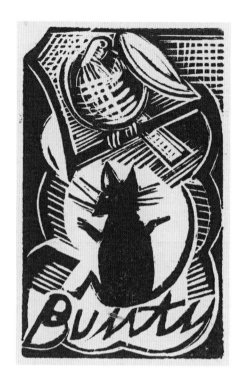

PAUL NASH
*Bookplate for
Samuel Courtauld*
1930
Wood engraving
11 × 8.3 cm

Samuel Courtauld (1876–1947) was a textile magnate, art collector
and co-founder of the Courtauld Institute of Art in London. He
commissioned this bookplate at a dinner party given by the writer and
radio producer Lance Sieveking and attended by Nash. The tall tower is
one of the chimneys, perhaps recently erected, of Courtaulds' Coventry
factory. The rectangular frame probably refers to the heddle or heald
frame used for weaving on a modern loom.

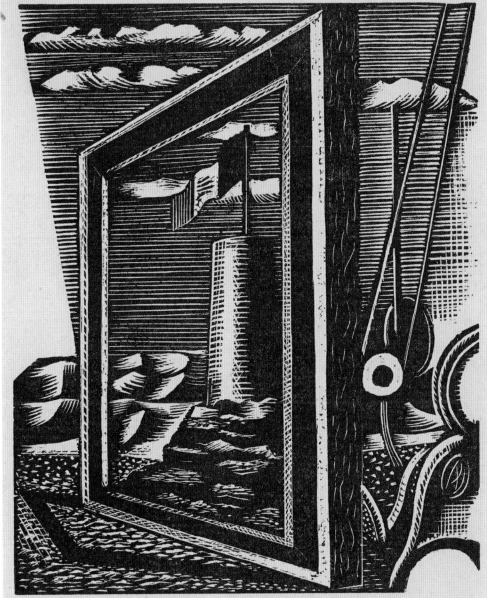

SAMUEL COURTAULD

LUCIEN PISSARRO
(1863–1944)
*Bookplate for Lucien and*
*Esther Pissarro*
*c.* 1920
Wood engraving
8.1 × 5.8 cm

Many of Lucien Pissarro's
wood engravings were
printed by his wife, Esther
Bensusan (1871–1951).
The Jewish couple
together ran the Eragny
Press, named after the
village in which Lucien's
father, the painter Camille
Pissarro, had lived and
worked in the latter part
of his career. The imagery
is redolent of the rural
paintings of the elder
Pissarro, but may also refer
to the lost tribes of Israel.

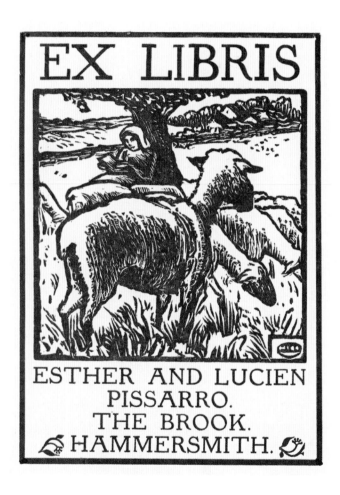

HUBERT
DUPOND
(1901–82)
*Bookplate for
Jules Grosfils*
*c.* 1925–35
Woodcut
14 × 9.2 cm

Jules Grosfils was
President of both
the Association
Belge des
Collectionneurs
et Dessinateurs
d'Ex-libris, and the
group La Gravure
Originale Belge.
Dupond also
made an intaglio
bookplate for him.

EX-LIBRIS
JULES GROSFILS

SYDNEY VACHER
(1854–1934)
*Bookplate for Herbert
Reginald Dear*
*c.* 1920
Etching
11.3 × 6.6 cm

Sydney Vacher
was an architect,
draughtsman and
print collector.
Herbert Dear
(b. 1876, d. ?)
was a collector
of Chinese Ming
dynasty porcelain,
which he sold to
the British Museum
in 1925. The bird
flying towards a lion
in this bookplate
may well have been
copied from a piece
of Chinese art in
Dear's collection.

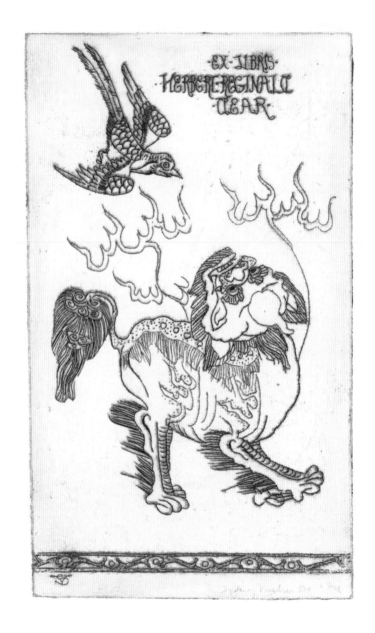

HERTHA FURTH
(b. 1907, d. ?)
*Bookplate for*
*Waldemar Kaempffert*
*c.* 1928–31
Colour woodcut
12.4 × 7.4 cm

This little-known
Austrian artist settled
in Chicago, where
Waldemar Bernhard
Kaempffert (1877–
1956) was appointed
as the first Director of
the Museum of Science
and Technology in
1928. Three years
later he moved to
New York to become
the science editor of
*The New York Times.*
Subjects on which
Kaempffert published
include astronomy,
represented in the
bookplate by the stars,
planet and moon, and
India, represented by
the Buddha, scimitar
and eastern dancing
girl.

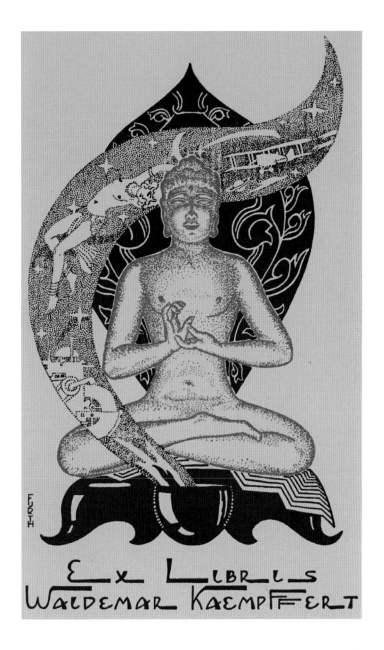

JOSEF VÁCHAL
(1884–1969)
*Bookplate for*
*Marie Paulusová*
1922
Woodcut
9.1 × 8 cm

The Czech artist
Váchal was one of
the most prolific
designers of *ex libris*
of all time, claiming
to have made over
650 bookplates. He
executed plates for a
number of members
of this family, one
of whom, Vincenc
Paulus, wrote about
the work of the
artist's wife, Anna
Mackova, another
bookplate artist.

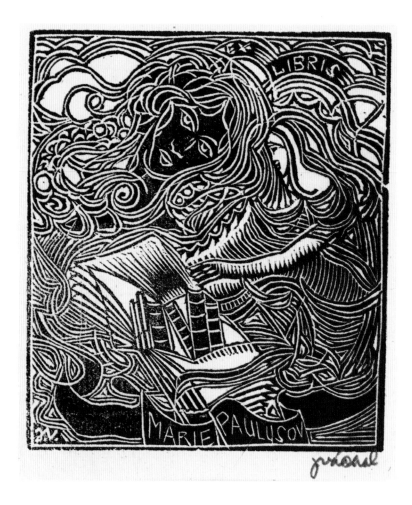

JOSEPH HECHT
(1891–1951)
*Bookplate for*
*A.E.G. Carthew*
*c.* 1926–8
Engraving
11.7 × 7.6 cm

Alice Grace Elizabeth
Carthew (1867–1940)
was a Hellenist and
translator of St John
Chrysostom. The
inscription in an
old Celtic language,
meaning 'Let us be wise
without guile', is the
motto of her family,
which was Cornish in
origin. The auk standing
on a rock featured on
the Carthew shield,
which is decorated
with three murrs
(auks). Alice Carthew
collected the work of
William Blake and stuck
other versions of this
bookplate into the front
of four books by him,
which she bequeathed
to the British Museum.

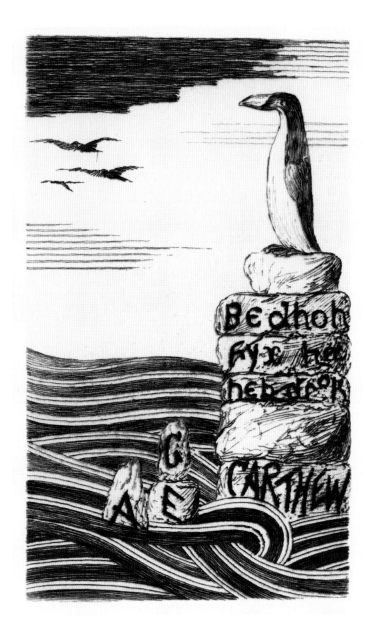

SIDNEY JAMES HUNT
(1896–1940)
*Bookplate for S.J.H.*
1923
Colour linocut
13.9 × 5.1 cm

The artist and poet Sidney
James Hunt was the
Secretary and Treasurer
of the English Bookplate
Society, and succeeded
James Guthrie as the
editor of *The Bookplate*.
Hunt's bookplate designs
of the period 1923–5
show that he was in touch
with modernist art in
Belgium and France.
His work stands out
in its advanced style as
being quite unlike that
of any of his British
contemporaries, including
that of his partner,
the engraver Herbert
Wauthier. In 1926–7
Hunt founded, edited and
published the avant-garde
journal *Ray*.

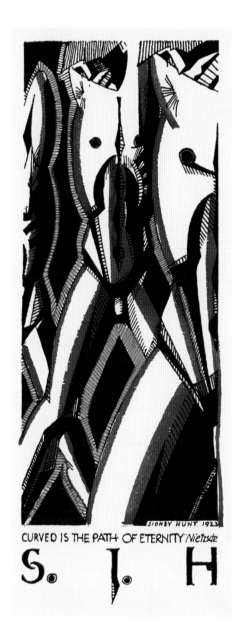

SIDNEY JAMES HUNT
*Bookplate for A.W.*
1923
Colour linocut
10.2 × 5.6 cm

As well as this bookplate for 'A.W.', Hunt made one for A. Whiteflower, which was perhaps a pseudonym he chose for himself for personal reasons. The Narcissus-like figure could be a self-portrait and might also be read as homoerotic; the artist may not have wanted to draw attention to his homosexuality at a time when it was still illegal.

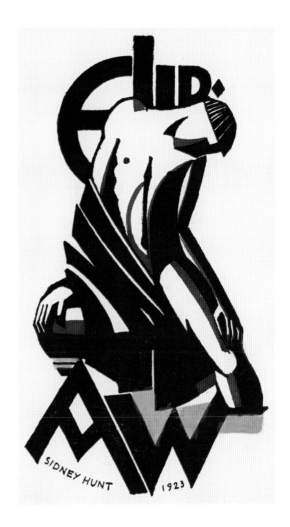

CHARLES THRUPP
NIGHTINGALE
(1878–*c.* 1927)
*Bookplate for*
*Harold Wright*
1923
Woodcut
9 × 6.5 cm

The leading print
historian and dealer
Harold James Lean
Wright (1885–1961)
worked as a director of
the London-based art
dealers P. & D. Colnaghi
& Co. The central
image of a monk seated
at a table is framed
by an inscription in
Latin. This is a slightly
shortened quotation
from the Roman
philosopher Seneca's
*Letters to Lucilius*
(LXXVI, 3, not 2 as
mistakenly cited on
the woodcut), which
translates as 'you should
learn as you do not
know and as long you
live'.

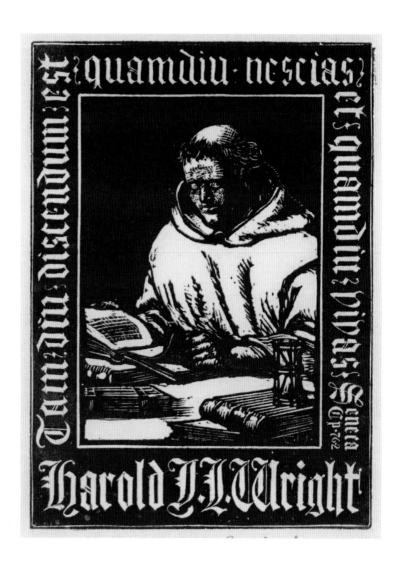

JOHN BUCKLAND
WRIGHT
(1897–1954)
*Bookplate for*
*M.B.B. Nijkerk*
1931
Wood engraving
5.8 × 3.8 cm

Bob Nijkerk (1894–
1987) was a Dutch
scrap-metal merchant
who lived in Brussels
for much of his life. A
notable bibliophile, his
collection was rich in
examples of illustrated
books and typography
and was the subject of
a major exhibition at
the Stedelijk Museum,
Amsterdam, in 1997.

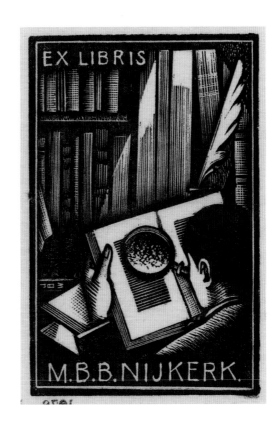

STANLEY
WILLIAM
HAYTER
(1901–88)
*Bookplate for*
*Maisie Reynolds*
1926
Engraving and
drypoint
8.7 × 6.4 cm

This early work
by the English
printmaker Hayter
represents a hilly
landscape near
the west coast of
Corsica, which he
visited in 1926.

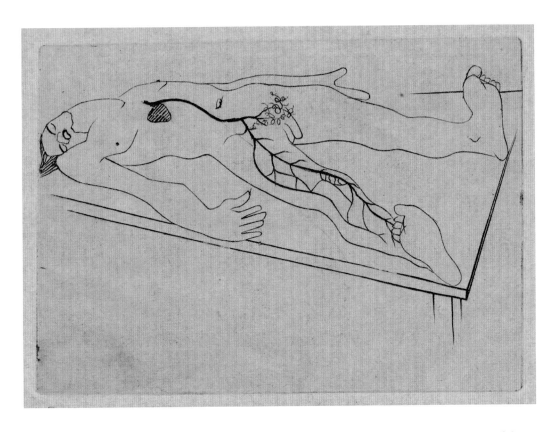

STANLEY WILLIAM HAYTER
*Bookplate for Grist*, 1930
Engraving, 6.2 × 8.9 cm

It has not so far been possible to identify the owner of this bookplate, who may have been a doctor or an anatomist.

TIMOTHY COLE
(1852–1931)
*Bookplate for President
Calvin Coolidge*
1928
Wood engraving
10.3 × 8.1 cm

Calvin Coolidge
(1872–1933) was
the Republican
President of the
United States from
1923 to 1929.
Commissioned
by one of his
supporters, this print
shows the President's
homestead in
Plymouth, Vermont.
The bust of Benjamin
Franklin in profile
refers to one of his
political heroes. Cole
based his print on
a drawing made by
another bookplate
artist, Sidney Lawton
Smith (1845–1929),
who may have been
too ill to execute a
print.

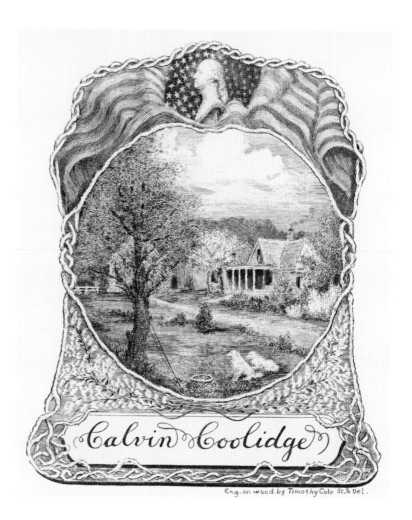

106

STEPHEN GOODEN
(1892–1955)
*Bookplate for*
*Ethel Luce-Clausen*
1940
Engraving
9.5 × 5.7 cm

At the time when this plate was made, Dr Ethel M. Luce-Clausen (b. 1887, d. ?) was working in the biological laboratories of the College of Arts and Sciences at the University of Rochester, New York, where she undertook experiments involving rats. Although she had stipulated that the artist should not include a rat in the bookplate, Gooden explained that 'the rat crept in when I wasn't looking'.

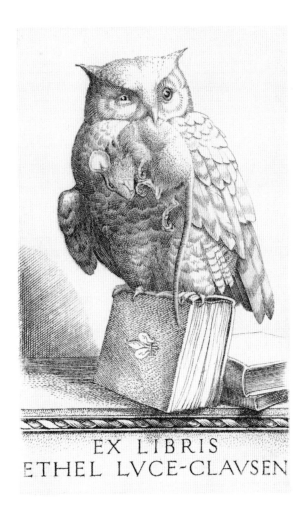

EX LIBRIS
ETHEL LVCE-CLAVSEN

MARK SEVERIN
(1906–87)
*The kitchen*
1979
Stipple engraving
9 × 8 cm

This is one of two
bookplates that
the Belgian artist
made for his fellow
countrywoman
Jeanne Rasdolsky, a
passionate collector
of *ex libris*. Severin
also designed three
bookplates for
Jeanne's husband,
Jacques Rasdolsky.

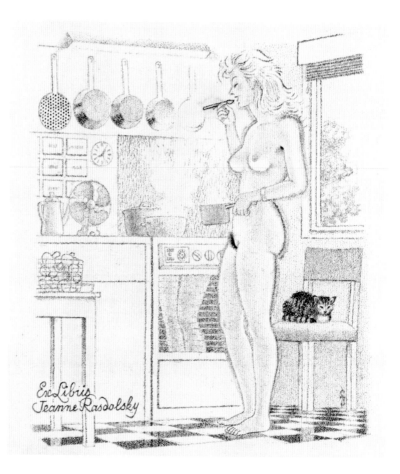

# FURTHER READING

There is no modern history of bookplates published in English, although there are many short volumes devoted to the bookplates of individual designers, and to subjects such as erotic bookplates, London bookplates, masonic bookplates, medical bookplates and musical bookplates, as well as to the bookplates of individual countries or regions. The writings of Brian North Lee, William Elliott Butler and John Blatchly are especially worth consulting on particular artists and topics. More can be found online on websites devoted to individual artists.

Much information can be gleaned from specialist journals, including:
*The Book of Book-plates*, 1900–3
*The Bookplate* (published by the English Bookplate Society), 1920–5
*The Bookplate* (published by the American Bookplate Society), 1914
*The Bookplate Annual*, 1921–5
*Bookplate International*, 1994–2005
*The Bookplate Journal*, 1983–
*The Bookplate Magazine*, 1919–21
*Journal of the Ex-Libris Society*, 1891/2–1908
*The Private Library*, 1958–

The following bibliographies published in English are also useful:
Audrey Spencer Arellanes, *Bookplates: a selective annotated bibliography of the periodical literature*, Detroit 1971
George W. Fuller, *Bibliography of bookplate literature*, Detroit 1973 (reprint of the 1926 Spokane edition)
José Vicente de Bragança and J. Stewart A. LeForte, ed., *The Art of the Ex Libris* (compiled 1998–2005): http://www.bookplate.info/Bookplate/bibliogr.pdf

# ILLUSTRATION CREDITS

The British Museum's substantial collection of bookplates was formed largely through the generosity of donors, notably the 1897 bequest of Sir Augustus Wollaston Franks and the gifts made by Max Rosenheim and George Heath Viner in 1932 and 1950 respectively. In addition Campbell Dodgson, Keeper of Prints and Drawings from 1912 to 1932, himself a major donor (see p. 64), made strenuous efforts to acquire bookplates by modern British and American engravers.

Photographs © The Trustees of the British Museum, courtesy of the Departments of Prints and Drawings and of Photography and Imaging. Every attempt has been made to trace accurate ownership of copyrighted works in this book. Errors and omissions will be corrected in subsequent editions provided notification is sent to the publisher.

*Page*
2 PD 1924,1211.8
10 PD 1900,0613.17
11 PD 1904,0206.153
12 PD 1979,U.685
13 PD 1950,0211.19.2
14 PD 2004,U.31 (Bequeathed by Sir Augustus Wollaston Franks)
15 PD 1951,0501.26 (Bequeathed by Campbell Dodgson)
16 PD 1904,0219.129
17 PD 1950,0520.390.9063 (Given by George Heath Viner); © Clausen Estate
18 PD 1915,1026.22
19 PD 1912,0930.34
20 PD 1915,1026.80
21 PD 1932,0721.49
22 PD 1950,0927.1 (Given by George Heath Viner)
23 PD 1932,0721.38
24 PD 1950,0520.390.7538 (Given by George Heath Viner)
25 PD 1931,0813.3
26 PD 1940,0701.6; © The Ashbee family
27 PD 2001,1125.13 (Given by Anthony and Julia Neuberger in memory of Walter and Alice Schwab); © DACS 2010
28 PD 950,0520.390.6770.a (Given by George Heath Viner)
29 PD 1935,0612.1 (Given by Mrs Ethel Alec Tweedie)
30 PD 1950,0520.390.9019 (Given by George Heath Viner)
31 PD 1912,0819.9
32 PD 2001,1125.12 (Given by Anthony and Julia Neuberger in memory of Walter and Alice Schwab)
33 PD 2001,1125.11 (Given by Anthony and Julia Neuberger in memory of Walter and Alice Schwab)
34 PD 1920,1009.15 (Given by John Dickson Batten)
35 PD 1920,1009.22 (Given by John Dickson Batten)
36 PD 1907,0930.473
37 PD 1907,0930.474
38 PD 1950,0520.390.9549 (Given by George Heath Viner); reproduced by permission of Desmond Banks
39 PD 1918,1024.3; reproduced by permission of Desmond Banks
40 PD 2006,U.1278
41 PD 1950,0520.390.7849 (Given by George Heath Viner)
42 PD 1950,0520.390.7201 (Given by George Heath Viner)
43 PD 1949,0411.1867 (Bequeathed by Campbell Dodgson)
44 PD 1912,0504.7
45 PD 1949,0411.4511 (Bequeathed by Campbell Dodgson)
46 PD 1950,0520.390.6998 (Given by George Heath Viner); © The Estate of Edward Gordon Craig
47 PD 1950,0520.390.7003 (Given by George Heath

Viner); © The Estate of
Edward Gordon Craig

48 PD 1933,0722.2 (Given by
Stewart Dick)

49 PD 1933,0722.4

50 PD 1907,0930.476

51 PD 1912,1109.20 (Given by
Charles Davies Sherborn)

52 PD 1920,0129.8

53 PD 1920,0129.4

54 PD 1916,1115.9

55 PD 1912,1104.2

56 PD 1950,0520.390.9085
(Given by George Heath
Viner)

57 PD 1909,0721.6

58 PD 1913,0717.766

59 PD 1949,0411.1592
(Bequeathed by Campbell
Dodgson); © The Estate of
Muirhead Bone

60 PD 1907,1130.8

61 PD 1907,1130.7

62 PD 1983,U.2576 (Given by
Mrs Theodore Rosenheim)

63 PD 1989,1104.335; © The
Estate of Voytech Preissig

64 PD 1909,0219.6 (Given by
Thomas Sturge Moore)

65 PD 1915,0521.3 (Given by
Thomas Sturge Moore)

66 PD 1920,0604.1 (Given by
Thomas Sturge Moore)

67 PD 1920,0604.2 (Given by
Thomas Sturge Moore)

68 PD 1915,0508.760 (Given by
George Heath Viner)

69 PD 1960,0409.618 (Given by
John Taylor Arms)

70 PD 1935,0410.9 (Given by
George Heath Viner)

71 PD 1950,0520.390.9061
(Given by George Heath
Viner); © The Estate of
Katherine Cameron

72 PD 1916,0428.6 (Given by
Campbell Dodgson)

73 PD 1930,0306.65 (Transferred
from the British Library)

74 PD 1920,1011.35

75 PD 1920,1011.9

76 PD 1997,U.39

77 PD 1924,0428.11

78 PD 1978,0121.385
(Bequeathed by Rudolf Josef
Weiss)

79 PD 1978,0121.402
(Bequeathed by Rudolf Josef
Weiss)

80 PD 1978,0121.390
(Bequeathed by Rudolf Josef
Weiss)

81 PD 1978,0121.405
(Bequeathed by Rudolf Josef
Weiss)

82 PD 1978,0121.358
(Bequeathed by Rudolf Josef
Weiss)

83 PD 1978,0121.396
(Bequeathed by Rudolf Josef
Weiss)

84 PD 1921,0112.2

85 PD 1919,1213.2 (Given by
Frank Weston Benson); © The
Estate of Frank Weston Benson

86 PD 1928,0707.22

87 PD 1928,0707.18

88 PD 1950,0520.390.9026

(Given by George Heath
Viner); © David Brangwyn

89 PD 1943,1211.453; © David
Brangwyn

90 PD 1932,0509.161

91 PD 1926,0927.3; © The Estate
of Albert Rutherston

92 PD 1970,0919.72.4; © Tate,
London, 2010-12-09

93 PD 1970,0919.72.6; © Tate,
London, 2010-12-09

94 PD 1997,U.27; © The Estate
of Lucien Pissarro

95 PD 1949,0411.4307
(Bequeathed by Campbell
Dodgson)

96 PD 1922,1228.4

97 PD 1938,0929.16

98 PD 1989,1104.394; © Dilia /
The Estate of Josef Váchal

99 PD 1935,0320.1

100 PD 1923,1203.21

101 PD 1923,1203.18

102 PD 1925,0314.32 (Given by
the Contemporary Art
Society)

103 PD 1978,0121.207
(Bequeathed by Mary
Buckland Wright); © The
Estate of John Buckland
Wright

104 PD 1988,0409.6; © ADAGP,
Paris and DACS, London 2010

105 PD 1988,0409.17; © ADAGP,
Paris and DACS, London 2010

106 PD 1932,0730.4

107 PD 1941,0516.1 (Given by
Ethel M. Luce-Clausen)

108 PD 1982,1211.22